Cyber Design:
Photography

C O M P U T E R -

M A N I P U L A T E D

P H O T O G R A P H Y

AB F 9141

First published in the United States of America by:
Rockport Publishers, Inc.
146 Granite Street
Rockport, Massachusetts 01966-1299
Telephone: (508) 546-9590
Fax: (508) 546-7141

Distributed to the book trade and art trade in the United States by:
North Light, an imprint of
F & W Publications
1507 Dana Avenue
Cincinnati, Ohio 45207
Telephone: (513) 531-2222

Other Distribution by:
Rockport Publishers, Inc.
Rockport, Massachusetts 01966-1299

ISBN 1-56496-218-0

10 9 8 7 6 5 4 3 2 1

Design/Layout: Beth Santos Design
Cover Photograph: (front) Ryszard Horowitz (back) Larry Melkus

Manufactured in Singapore by Regent Production Services Pte. Ltd.

Cyber Design:
Photography

C O M P U T E R -

M A N I P U L A T E D

P H O T O G R A P H Y

ROCKPORT
PUBLISHERS

Rockport Publishers, Rockport, Massachusetts
Distributed By North Light Books, Cincinnati, Ohio

Introduction

We are in the **midst of a revolution,** and for the first time in the long and violent history of revolutions. we can now say "off with their heads" and it's a good thing.

All it takes is a little **computing power,** and you can take their heads off easily enough (and do a few other **tricks** as you will **discover** in this book).

But before we get carried away with the **"how-did-they-do-that".** and before we start comparing whose computer is bigger. it might be worthwhile to examine how all this **technology** is affecting the human beings involved. Specifically. how has the process of creating computer-affected photography. with all its **unique pre-press requirements.** changed the way client. photographer. illustrator. and art director interact? I'm convinced that a **change** of habit is required—that the people involved have to learn to work differently with each other—but. as you will see. with the right group of creatives. the **results** can be **breathtaking.**

In the old days (oh. say five years ago). when a project needed photography. it was the **photographer,** not surprisingly. who held the **key** to the **successful realization** of the **idea.** The darkroom could help. re-touching could help. but in large part it was up to the "lone wolf" commercial photographer to go out alone and bring back the image (take it or leave it).

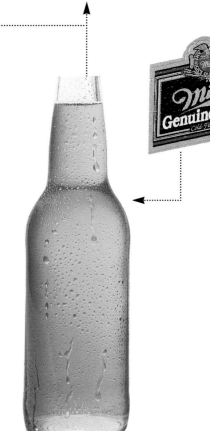

Those days, in large part, are over. Today, it's a **team effort** with much more emphasis on **pre-shoot planning.** What to the untrained eye looks like a **manipulated** single image may in fact be a **composite** of six or more **images,** or hundreds. The point is, the **photographer, computer illustrator,** and **art director** have to sit down and **collectively** determine how many shots, **angle by angle,** a particular idea is going to require.

This **collaborative process** has also changed the role of the illustrator. With specialized knowledge of the computer, **illustrators** have gone from simply executing ideas to adding input at the beginning of the **creative** process. Since they are at the **vanguard** of the **technology,** they can suggest **enhancements** to the **concept** that the art director or client may not even know are possible.

Finally, I would humbly suggest that for the creative process to really work, for the **end result** to be **breakthrough** advertising, something **counter-intuitive** has to take place. That is, everyone involved needs to remember that it isn't the hardware or software that's going to **make the difference.** A bad idea is still a bad idea no matter how much it's manipulated.

Which is reassuring, because even in the **midst** of a **digital revolution** where you can get your noggin chopped off easily enough, the one thing the computer can't do to your head is add that **light bulb** right above it.

Bill Jenkins
Studio 212°
Dallas, Texas

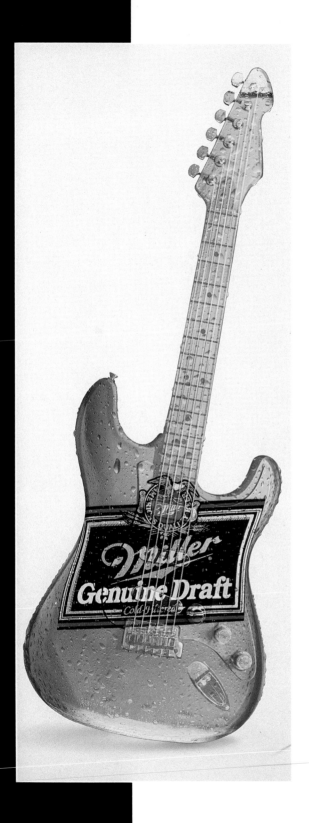

5

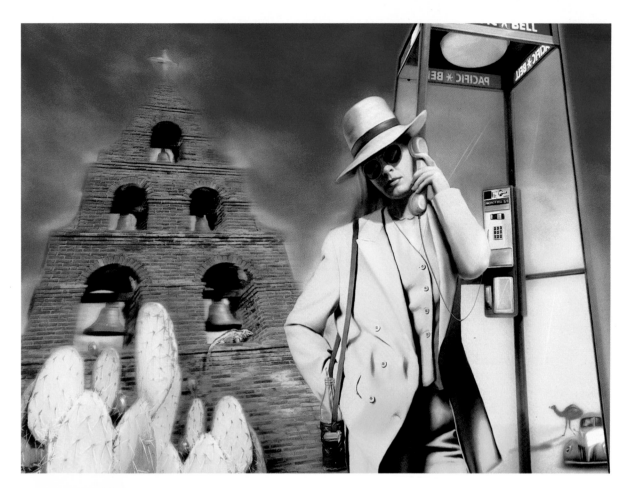

Design Firm EB Graphics
All Design Elaine Benson
Hardware Macintosh Quadra
950, HP Color Scanner
Software Adobe Photoshop
Client Self-Promotion

This image pushes the traditional limits of photography. The original scans were touched up, then distorted and composited in grayscale mode. Next, color was added, and each object was individually "smudged" for a painterly effect. The image was created entirely in Photoshop.

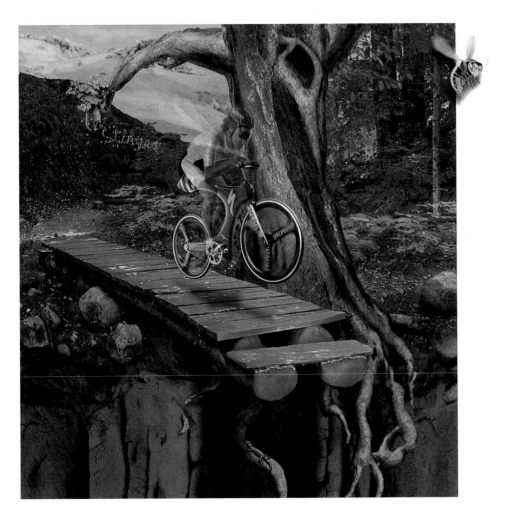

Design Firm EB Graphics
Designer Elaine Benson
Art Director Jerry Hoffman
Illustrator Elaine Benson
Photographer Jerry Hoffman
Hardware Macintosh Quadra 950.
 HP Color Scanner
Software Adobe Photoshop
Client Specialized Bicycles

The design goal here was to create an image that would attract new markets for the client, and would strengthen their corporate image. One of the major challenges in composing a group of photos is making sure the perspective, angles, and lighting of each image is correct, or at least believable. The computer allowed the designers total and immediate control of this.

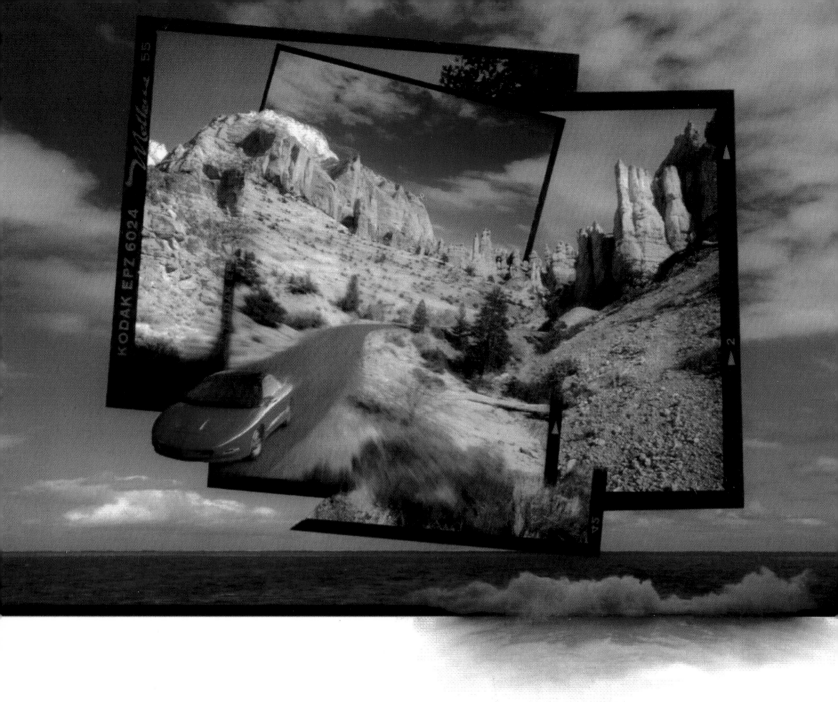

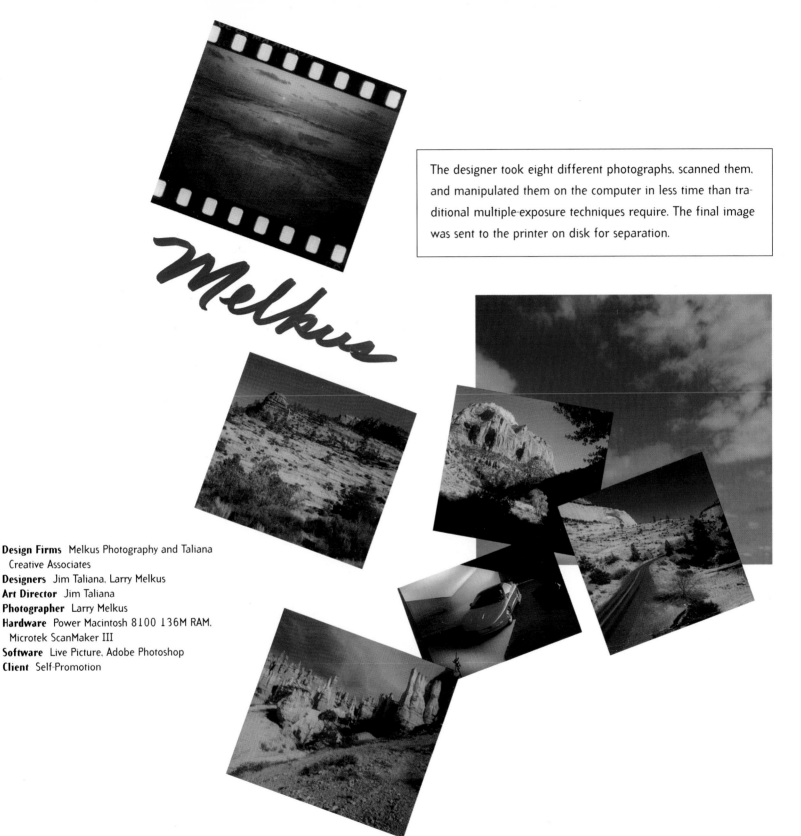

The designer took eight different photographs, scanned them, and manipulated them on the computer in less time than traditional multiple-exposure techniques require. The final image was sent to the printer on disk for separation.

Design Firms Melkus Photography and Taliana
 Creative Associates
Designers Jim Taliana, Larry Melkus
Art Director Jim Taliana
Photographer Larry Melkus
Hardware Power Macintosh 8100 136M RAM,
 Microtek ScanMaker III
Software Live Picture, Adobe Photoshop
Client Self-Promotion

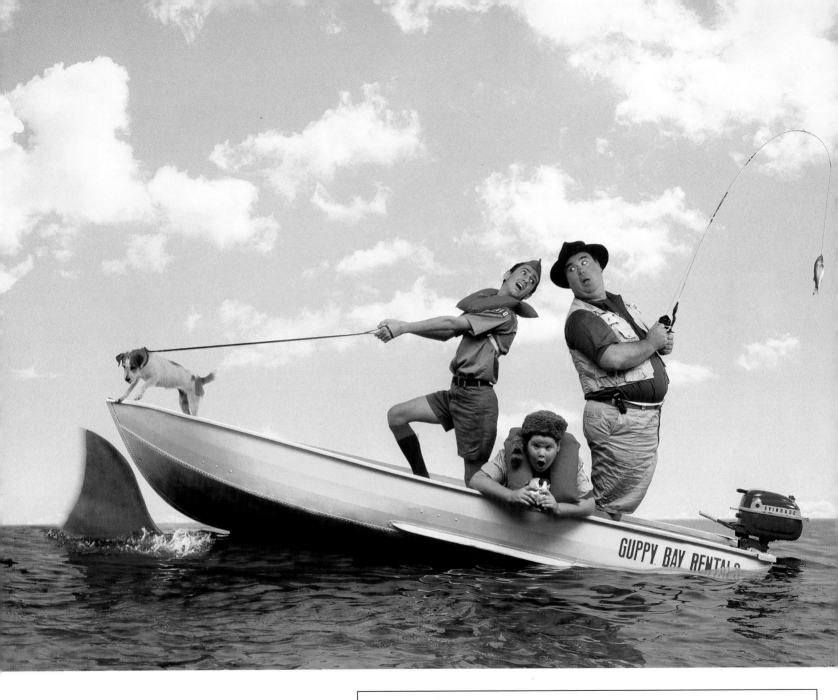

Design Firm David Blattel Studios
Art Director John Cecconi
Computer Artist Dennis Dunbar, Phaedrus Pro
Photographer David Blattel
Stylist Kim Pretti
Hardware Macintosh
Software Adobe Photoshop, Adobe Illustrator
Client Self-Promotion

The design goal was to create a humorous self-promotion with production value. The image was shot in-studio, using an artificial bay with real water. The boy was photographed holding an empty leash, and the dog, the background, and the splash around the shark fin were later added by computer. Background was also added at a later time and was an existing stock image.

Design Firm Ikkanda Design
Designer Richard Ikkanda
Art Director David Blattel
Computer Artist Tom Slatsky @ Outerspace
Photographer David Blattel
Hardware Quantel Graphic Paintbox®
Stylist Kim Pretti
Make-up Artists James MacKinnon, Jennifer Mann
Client ADCO Lithographers

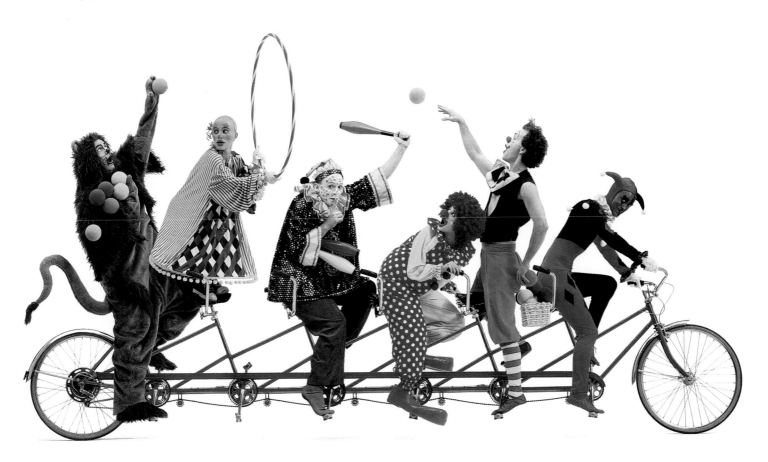

This image was created to promote ADCO's 6-color press. A two-person bicycle was photographed, then digitally expanded for six passengers. All of the clowns (a total of three models) were photographed individually. Each clown photo was then polarized and pasted on the bike.

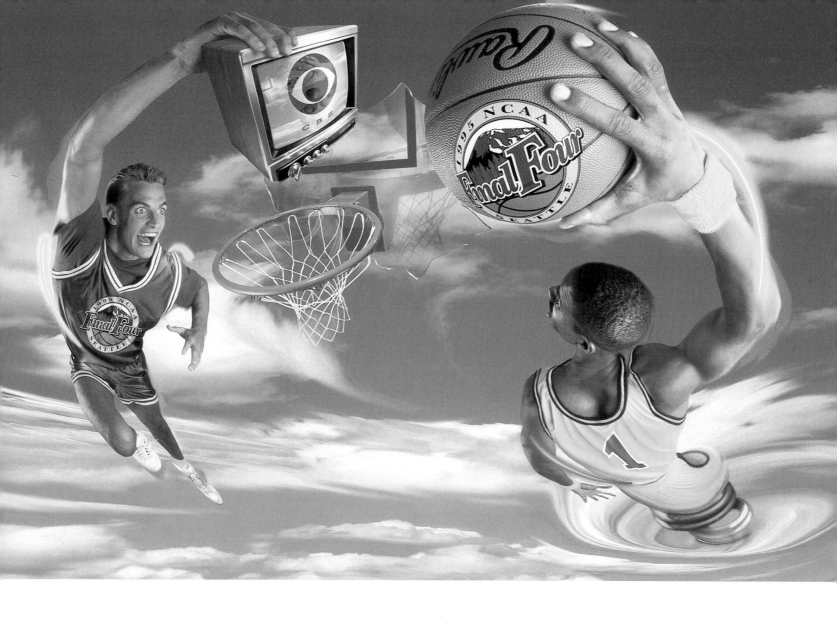

Design Firm Studio 212°
Designers Thai Nguyen, Mike Apodoka
Art Directors Thai Nguyen, Mike Apodoka
Illustrator Studio 212°
Photographer Jay Silverman
Hardware Quantel Graphic Paintbox®
Software Quantel Graphic Paintbox®
Client Frito Lay/BBD Needham

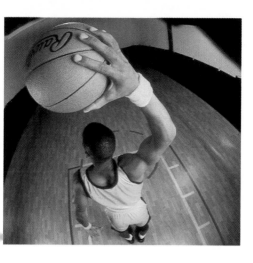

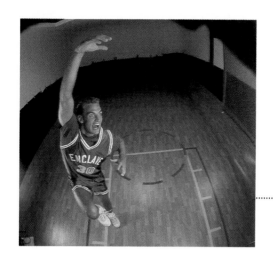

CBS

These basketball players were formed by merging approximately six photos to create each figure. The "twist" on the right hand figure was illustrated into the sky vortex.

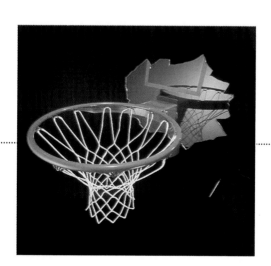

Design Firm David Blattel Studios
Art Director David Blattel
Computer Artist Dennis Dunbar,
 Phaedrus Pro
Photographer David Blattel
Stylist Alexandra Jordan
Hardware Macintosh
Software Adobe Photoshop,
 Adobe Illustrator
Client Self-Promotion

The Miata automobile was photographed parked on a winding road, using a zoom lens (zoomed during exposure) to create the feeling of motion. The passengers were photographed later, and their images were dropped in digitally by computer, then blurred to match the car. The "Road Closed" sign was a miniature that was also shot separately and added by computer.

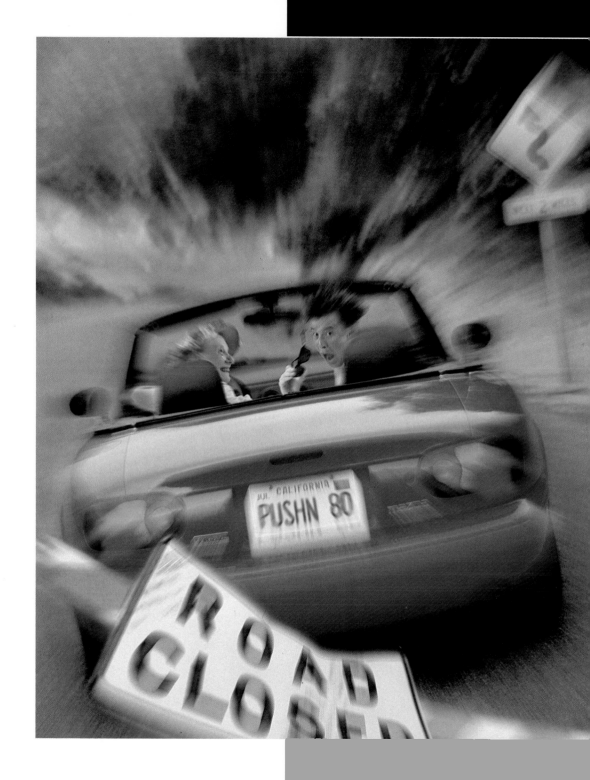

Design Firm J. Walter Thompson,
R/GA Digital Studios
Digital Design R/GA Print
2-D, 3-D Animation R/GA Print
Photographer Stock Image
Hardware Macintosh, Silicon Graphics
workstation
Software Imrender, Adobe Photoshop
Client Kodak

The design firm digitally bent the world's most famous skyscraper in this advertisement. Visual effects include three-dimensional image warping and digital retouching to correct color and to add light.

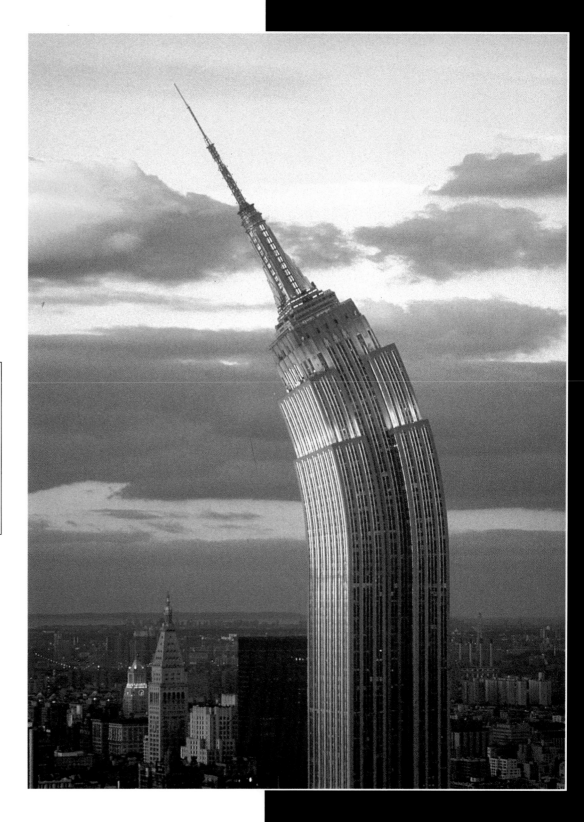

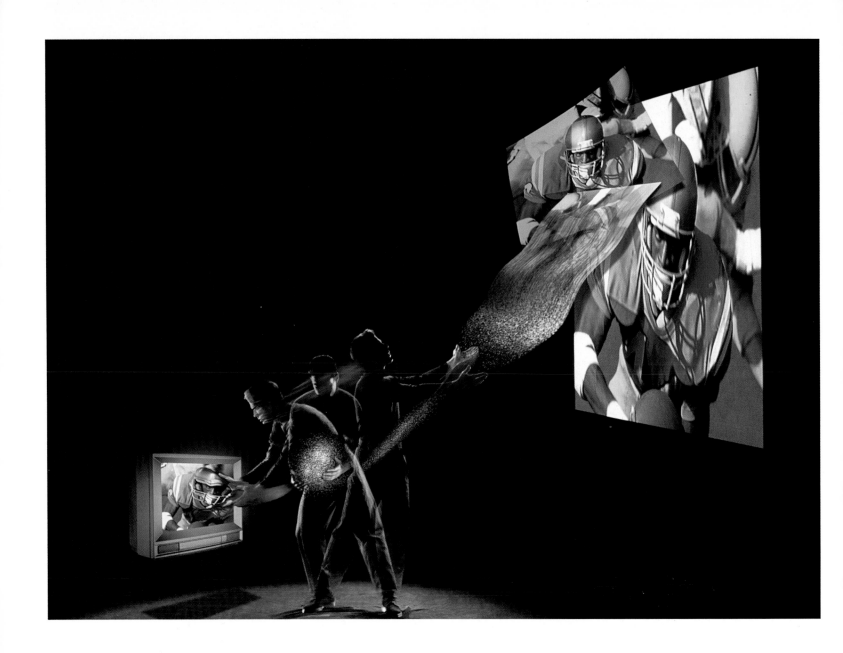

Design Firm Griffin Bacal, R/GA Digital Studios
Art Director Burt Blum
Digital Design R/GA Print
2-D, 3-D Animation R/GA Print
Photographer Ryszard Horowitz
Hardware Macintosh, Silicon Graphics workstation
Software Imrender, Adobe Photoshop
Client Sharp

This design of a seemingly motion-blurred photograph was created with the use of particle field, propriety software. The screen image was warped and original photography was digitally manipulated.

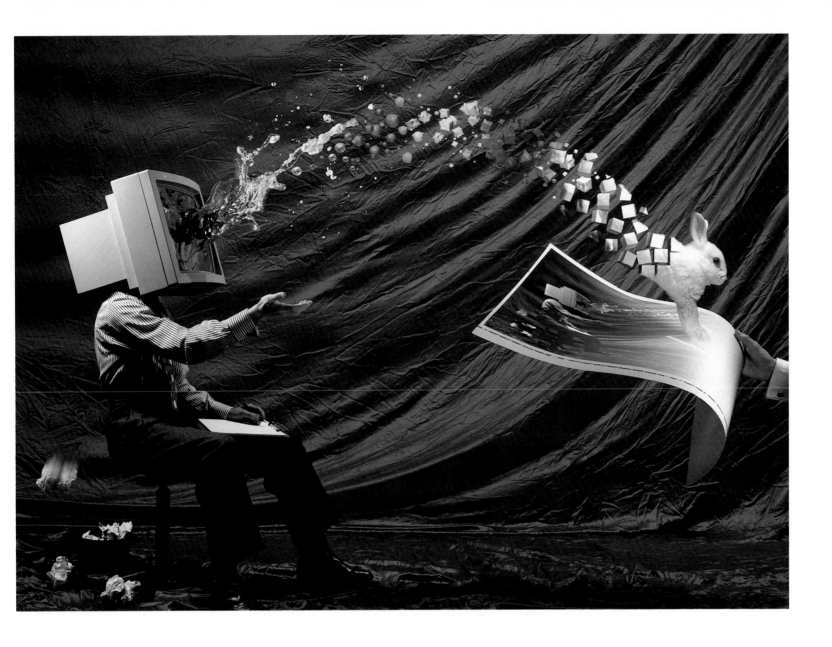

Design Firm Designthing
Designer Mark Von Ulrich
Digital Design R/GA Print
2-D, 3-D Animation R/GA Print
Photographer Ryszard Horowitz
Hardware Macintosh, Silicon Graphics workstation
Software Imrender, Adobe Photoshop
Client Washburn Graphics

A metaphor for the magic of the digital imaging process, this image combines photographic elements with visual effects. Designers used three-dimensional imaging, compositing, retouching, and color correction to develop this design.

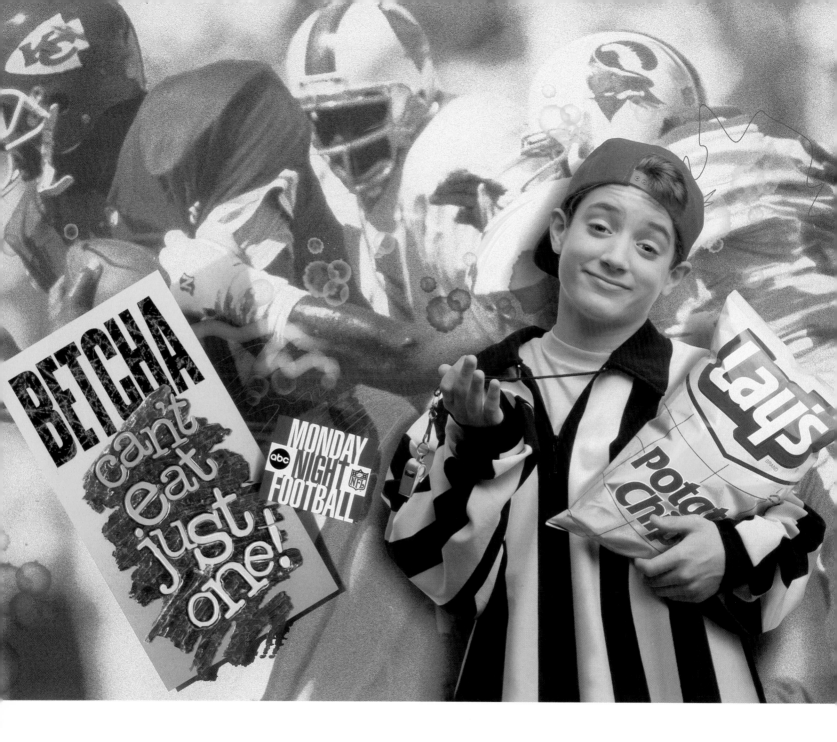

Design Firm Studio 212°
Designer Mike Apodaca
Photographer Jay Silverman
Illustrator Studio 212°
Hardware Quantel Graphic Paintbox®
Software Quantel Graphic Paintbox®

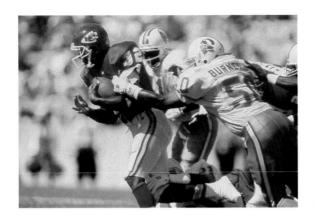

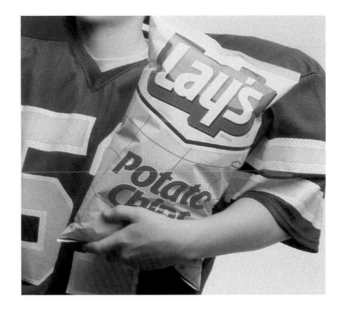

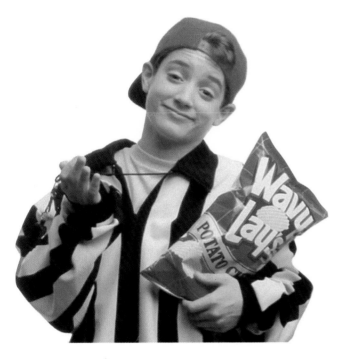

The background for this image was taken from stock football photographs. Textures were applied in Paintbox and then colorized. The logo was created on computer and placed into the image along with the photograph of actor Elijah Wood. Shadows were then added to create depth, and splatters were scanned in and colored for added interest.

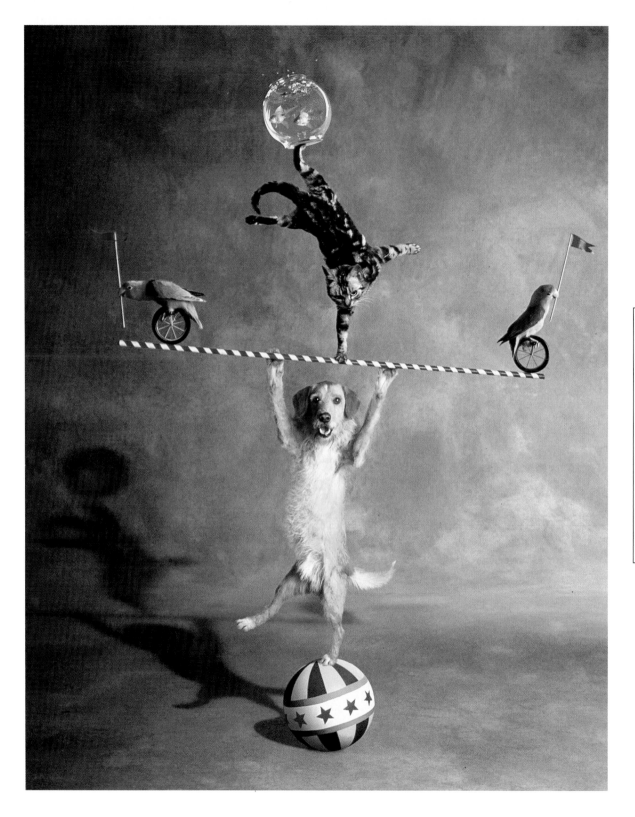

Design Firm Schell Mullaney
2-D Image Processing R/GA Print
Digital Design R/GA Print
Photographer Howard Berman
Hardware Macintosh
Software Adobe Photoshop
Client Computer Associates

For this playful advertise-ment, artists digitally integrated individual photographs of animals to create a circus act performed by household pets. Computer effects include the digitally gen-erated shadow that helps add realism to this diffi-cult balance of elements.

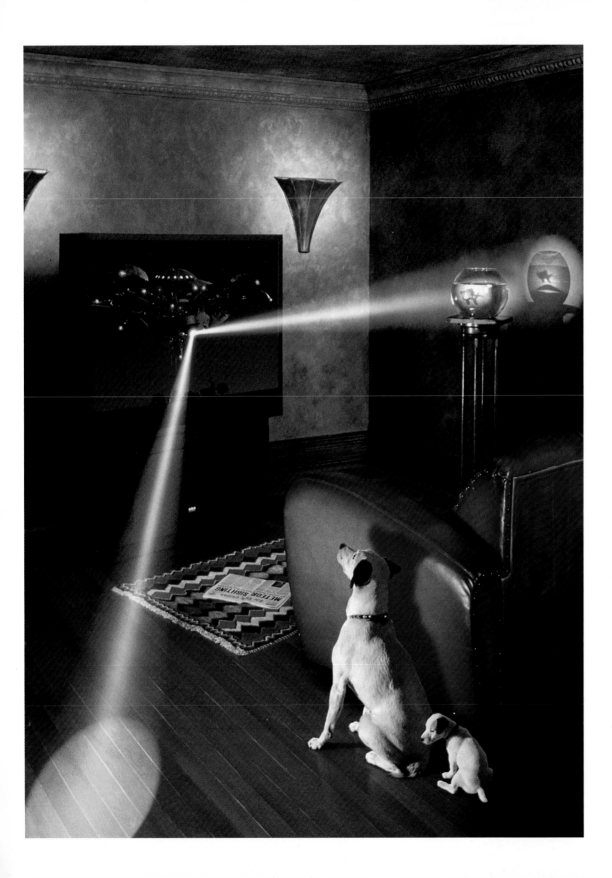

Design Firm Ammirati & Puris,
R/GA Digital Studios
2-D Image Processing R/GA Print
Digital Design R/GA Print
Photographer Craig Cutler
Hardware Macintosh
Software Adobe Photoshop
Client RCA

Designers composited individual photographic elements with digitally generated shadows and light beams for this television advertising campaign.

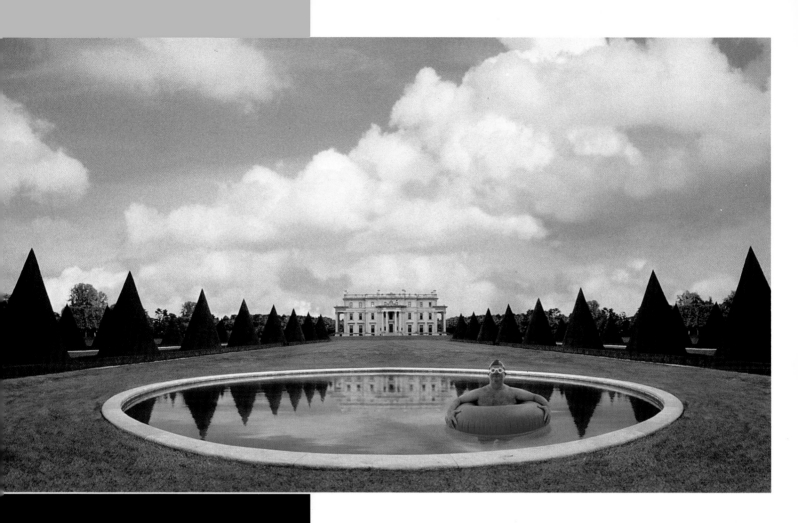

Design Firm DDB Needham
2-D Image Processing R/GA Print
Digital Design R/GA Print
Photographer Howard Berman
Hardware Macintosh
Software Adobe Photoshop
Client NY Lotto

Designers combined original photography with stock images of a French chateau to bring a common fantasy to life for this award-winning advertising campaign. Digital compositing was used to place the man in the pool, to add the chateau and the clouds, and to place the conical trees in the background. Pool reflections, color correction, and the elongation of the chateau in the picture were all accomplished with a computer.

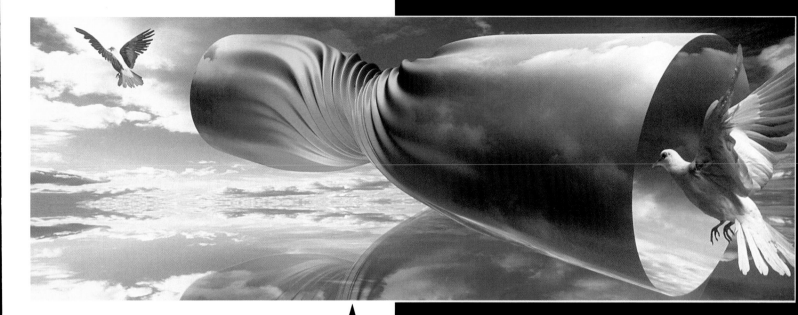

Design Firm R/GA Digital Studios
Digital Design R/GA Print
2-D, 3-D Animation R/GA Print
Photographer Ryszard Horowitz
Hardware Macintosh, Silicon Graphics workstation
Software Imrender, Adobe Photoshop
Client Self-Promotion

This image combines multiple photographic elements, including original photography and selections from photographs, with a computer-generated three-dimensional tube.

Design Firm Millennium Studios
Designer Denis Dale
Art Director Denis Dale
Photographer Denis Dale
Hardware Macintosh IIX, Leafscan 45
Software Adobe Photoshop
Client Sample Fine Art

This piece was designed to document the 1993 flood of the Mississippi river. The designer scanned in the original images and digitally recombined them in Photoshop. The new combinations were created with individual bits of visual information and suggest the despair experienced in the flood.

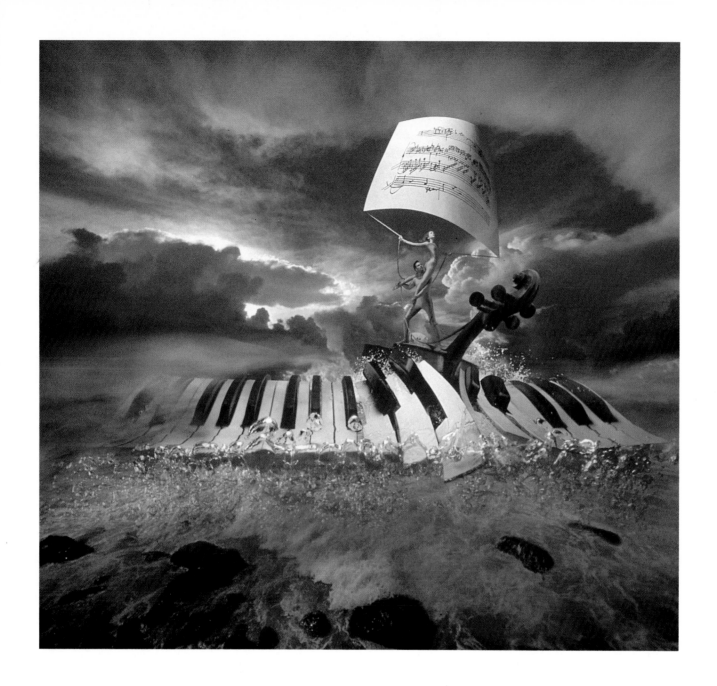

Design Firm Rumrill-Hoyt, R/GA Digital Studios
Digital Design R/GA Print
2-D, 3-D Animation R/GA Print
Photographer Ryszard Horowitz
Hardware Macintosh, Silicon Graphics workstation
Software Imrender, Adobe Photoshop
Client Kodak

This image demonstrates the collaborative imaging process. Three-dimensional imaging of the piano keys, digital retouching, and layer composition were used to develop the piece.

Design Firm Burke/Triolo
Designers Jeffrey Burke, Lorraine Triolo
Photographer Jeffrey Burke
Digital Manipulation Jeffrey Burke
Hardware Macintosh Quadra 950, 130M, Wacom Tablet
Software Adobe Photoshop 2.5.1, Photo CD Aquire Module
Client Self-Promotion

This image was set up as a still-life in-studio with a small amount of soap suds added to the rock surface. A single, glass ball was also photographed against a black background, and the two shots were scanned onto a Photo CD. The ball was then repeatedly duplicated over the main image with the "lighten only" tool, and the soap suds were copied, pasted, distorted, and pasted again until the image looked sufficiently wet.

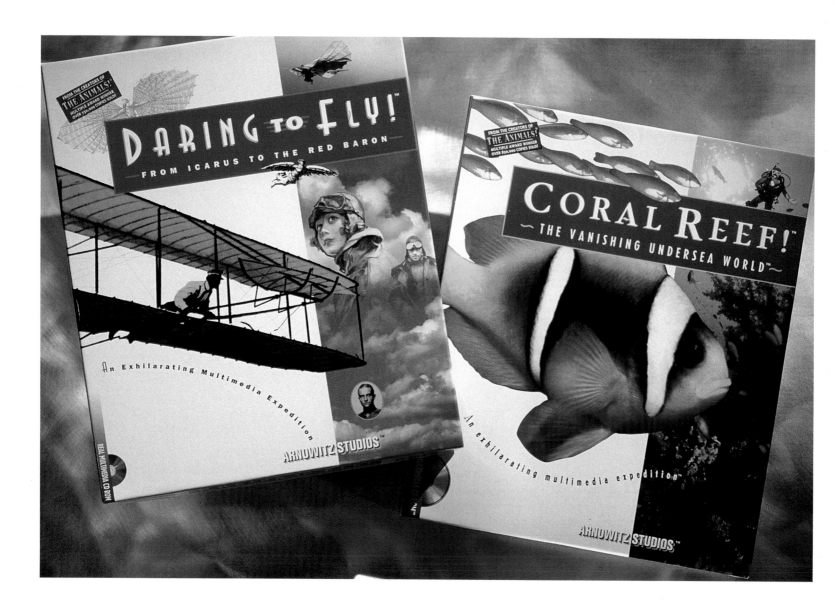

Design Firm Jamie Davison Design, Inc.
Designer Keith Owejs
Art Director Jamie Davison
Illustrator Gracie Artemis
Photographer Bettman Archives National Air & Space Museum
Hardware Macintosh Power PC 7100, PLI 44M Syquest Drive
Software Adobe Illustrator 5.5, Adobe Photoshop
Client Arnowitz Studios

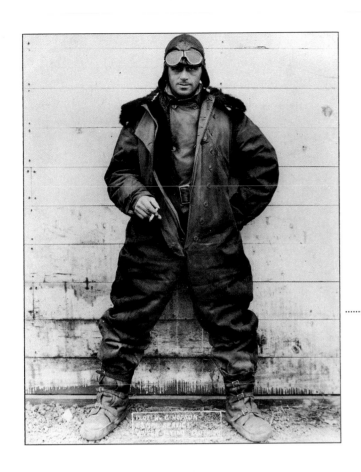

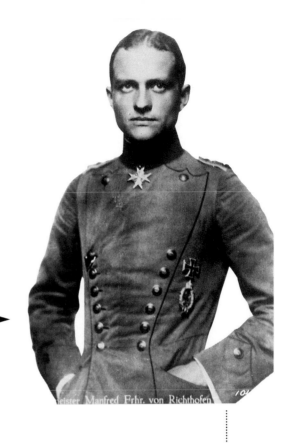

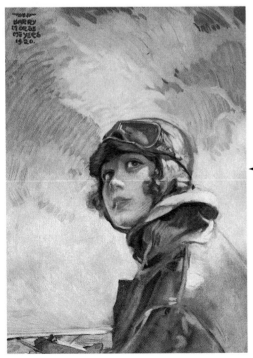

This product packaging design includes historical photographs of the Wright brothers and other famous aviators. Along with a stock photo of a cloudy sky, these archival images were merged together in Photoshop to create a photo montage. The old images convey the drama and history of flight, while the layering of images communicates the large amount of information available with this product.

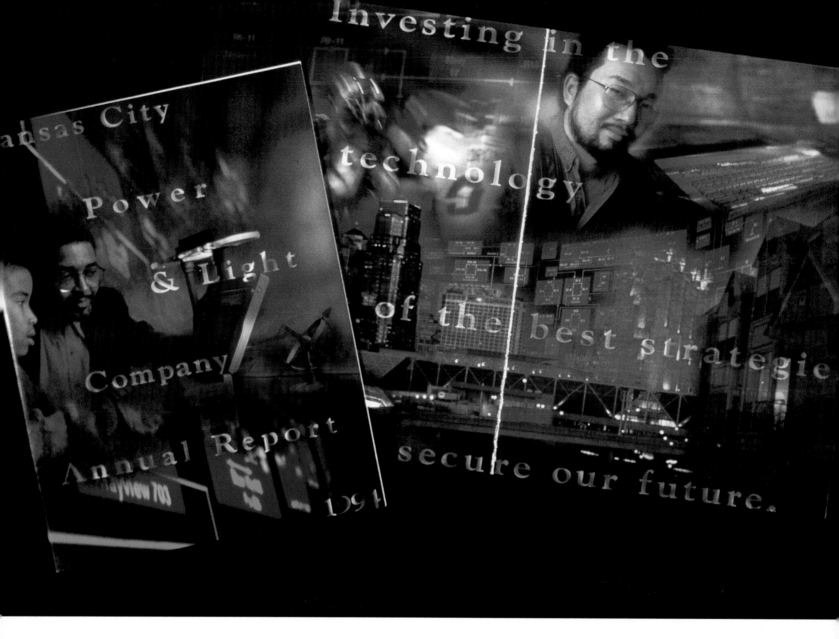

Design Firm Muller + Company
Designer Susan Wilson
Art Director Susan Wilson
Photoshop Retoucher Elise Ray
Photographer Michael Regnier
Hardware Power Macintosh
Software Adobe Photoshop. QuarkXPress
Client Kansas City Power & Light

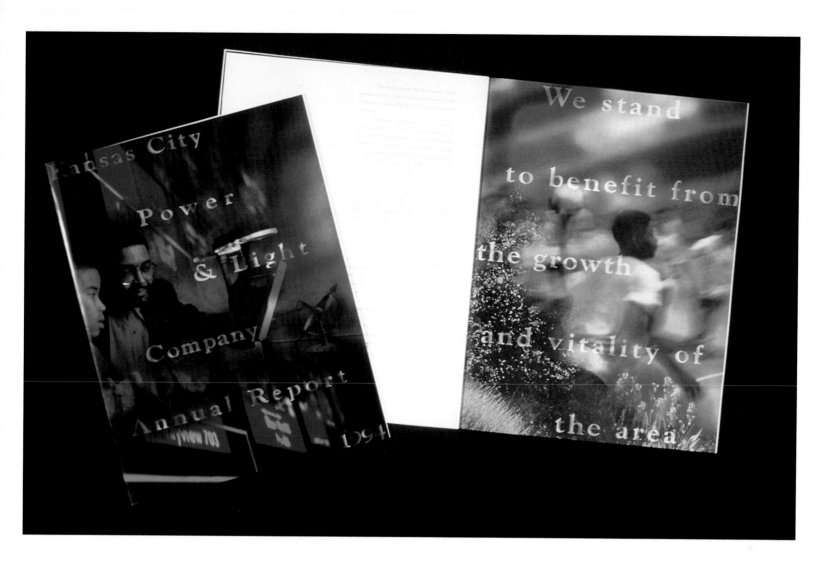

The challenge for this annual report was to create a piece that reflected the client's history of being technologically advanced, and to represent the diversity of employees, customers, and partner companies. Visuals were identified and shot individually (a combination of studio and location) then merged in Photoshop. Type was set in QuarkXPress and combined with the image.

Design Firm Mervil Paylor Design
Designer Mervil M. Paylor
Art Director Mervil M. Paylor
Photographer Mervil M. Paylor
Digital Manipulation Ron Chapple.
 David Pitts
Hardware Quadra 700
Software Adobe Photoshop 2.5.
 Aldus PageMaker 5. Aldus Trapwise
Client First Union Corporation

Stock photographs were printed as duotones in a nontraditional way. Certain areas of each photo were manipulated to create pure halftones and second-color duotones. These images were converted to grayscale and then duotone mode in Photoshop. Here, the duotones were created, allowing for experimentation with certain inks.

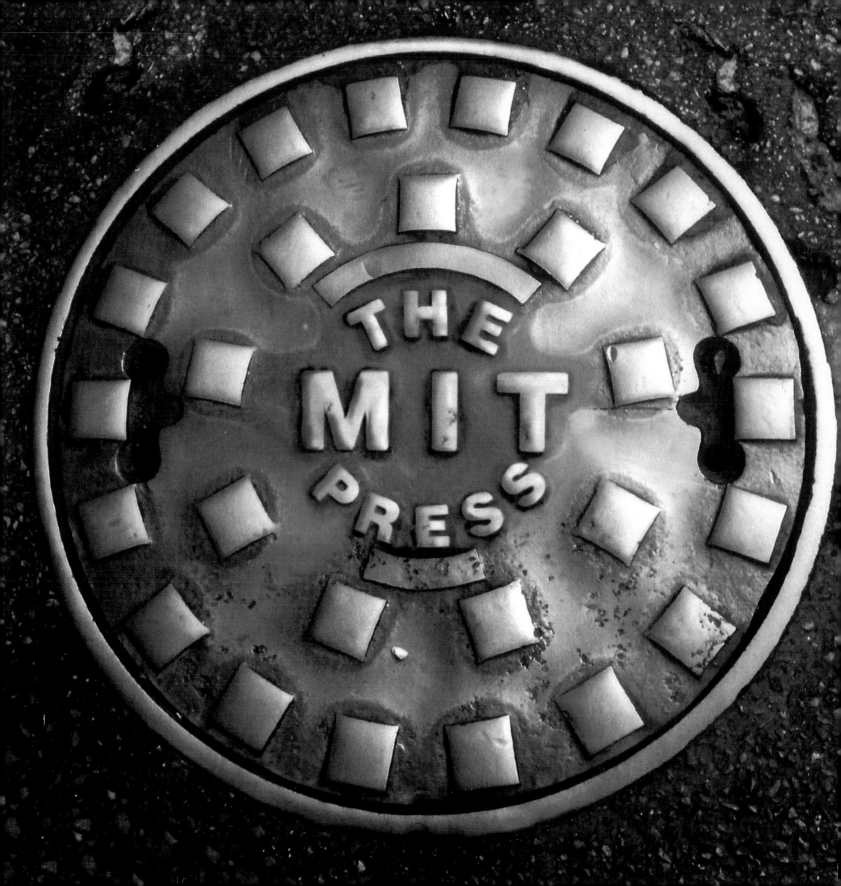

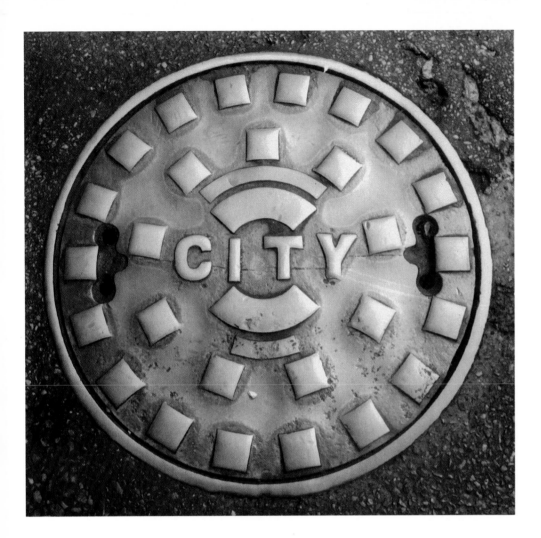

Design Firm Lightstream
Designer Karen Shea
Illustrator Albert Mallette
Photographer Robert A. Melnick
Hardware 840 AV Macintosh
Software Adobe Photoshop. Adobe Illustrator
Client MIT Press

This cover for the MIT Press catalog puts the publisher's logo on a photograph of a manhole cover. Low-resolution scans were first type-formatted in Illustrator; type was then used as a template for illustration in Photoshop.

The goal for this trade show video display was to design a "New Age island" of images and sound. Designers created a variety of original three-dimensional shapes, digitally altered them, then combined them with stock photography. Photographic backgrounds and three-dimensional objects were then assembled in Photoshop using composite controls and filtering techniques. The images were then programmed to a musical soundtrack.

Design Firm The Vision Factory
Designer Cince Conti
Art Director Paola Curcio
Photographer Angelo Merluccio
Client Self-Promotion

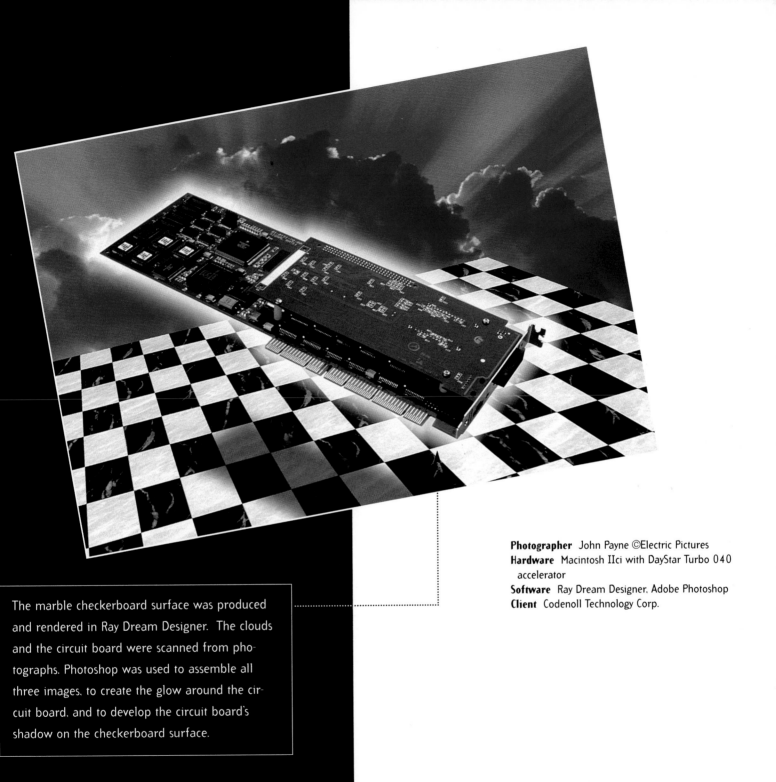

Photographer John Payne ©Electric Pictures
Hardware Macintosh IIci with DayStar Turbo 040 accelerator
Software Ray Dream Designer. Adobe Photoshop
Client Codenoll Technology Corp.

The marble checkerboard surface was produced and rendered in Ray Dream Designer. The clouds and the circuit board were scanned from photographs. Photoshop was used to assemble all three images. to create the glow around the circuit board. and to develop the circuit board's shadow on the checkerboard surface.

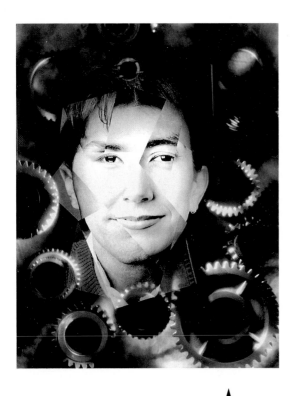

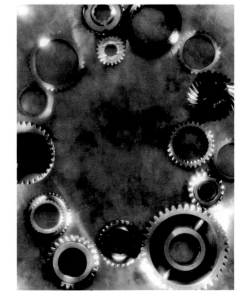

Design Firm Vaughn Wedeen Creative
Designer Dan Flynn
Art Directors Steve Wedeen, Dan Flynn
Illustrators Rick Vaughn, Chip Wyly
Computer Production Chip Wyly
Hardware Macintosh Quadra 840 AV, Radius
 Intellicolor 20e Display, Apple 13-inch
 Hi-Res RGB
Software Aldus FreeHand, Adobe Photoshop,
 QuarkXPress
Client US West Small Business Group

The versitality of Photoshop and its layer features enabled designers to create a more accurate and timely composition of this face than would have been possible with traditional techniques.

Design Firm S.P. Richards Design Group
Designer Charles Davis
Art Director Charles Davis
Photographer Jim DiVitale
Hardware Power Macintosh 8100 AV, Leafscan 45
Software Adobe Photoshop 3.0, Kai's Power Tools

The original photographs for this design were taken with a digital camera, then layered and enhanced in Photoshop. To create the background, designers used a graduated color palette from Kai's Power Tools.

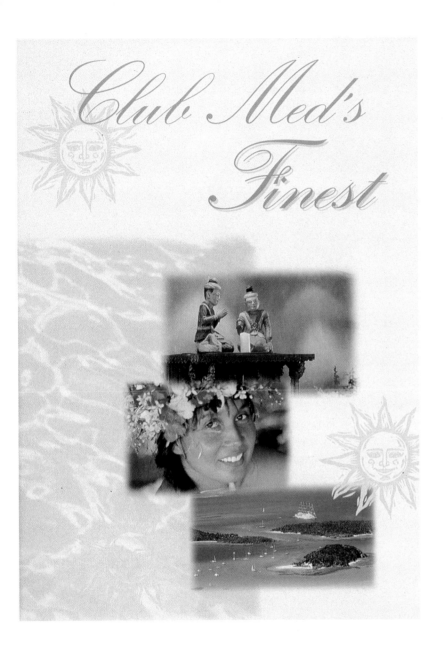

Club Med's Finest

Design Firm O & J Design, Inc.
Designer Lia Camara-Mariscal
Art Director Andrew Jablonski
Hardware Macintosh Quadra 800, Apple CD ROM
Software Adobe Photoshop 3.0, QuarkXPress 3.3
Client Club Med

The design objective was to create a single, rich and dreamy image for the Club Med's Finest brochure, by combining various photos. Edges of the photographs were feathered and blended into each other using Photoshop's channels. An ordinary photograph of the ocean was manipulated in Photoshop and printed in a metallic color, creating an abstract background texture.

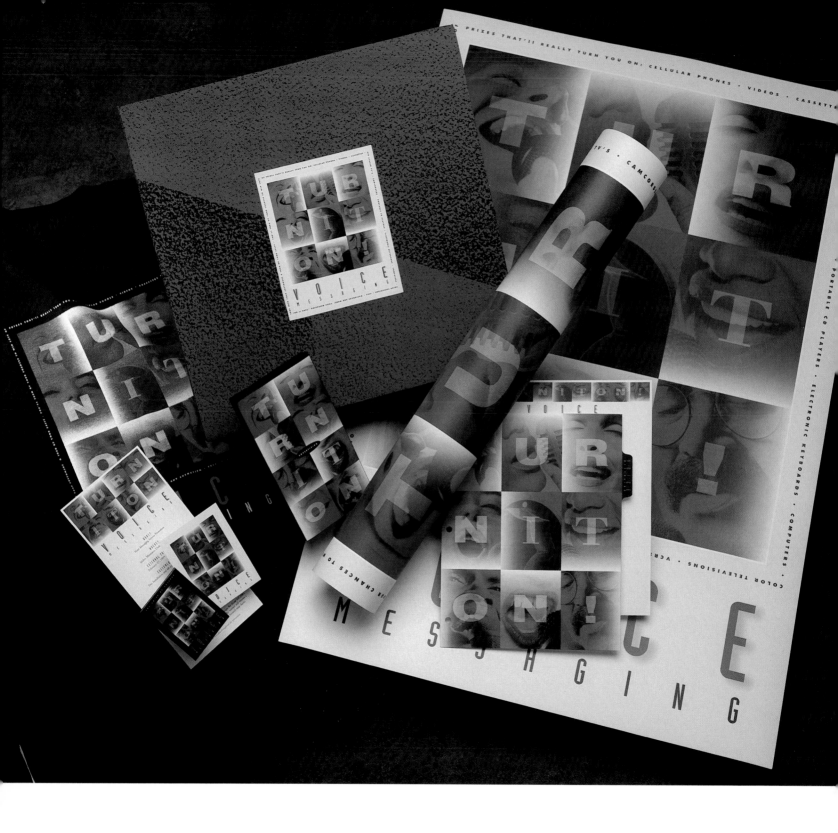

Design Firm Vaughn Wedeen Creative
Designer Rick Vaughn
Art Director Rick Vaughn
Computer Production Chip Wyly
Hardware Power PC 8100/80AV
Software Adobe Photoshop. QuarkXPress
Client US West H & Ps

The major challenge was to make the graphic design reinforce the product's "voice messaging." By showing people singing and by gradating out the photographs. the "voice" element comes through all aspects of the design. Traditional methods of gradation are very time consuming; here, the gradation was easily manipulated and controlled with the computer.

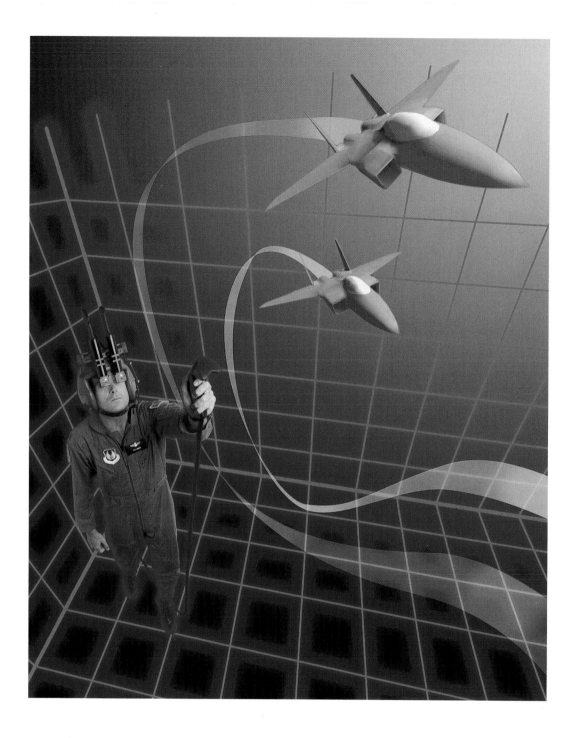

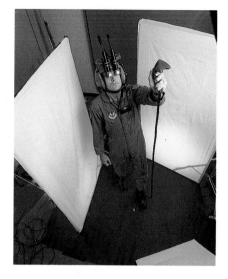

Design Firm Research Communications
 Center
All Design Brian Watkins
Hardware Quadra 950, 72M RAM,
 Leafscan 45
Software Adobe Photoshop 2.5,
 Macromedia's Swivel 3-D
Client UDRI

The design goal was to emphasize the expanding interaction between humans and technology, specifically in the areas of simulation and pilot training. The photograph of the pilot was scanned into the computer, and a neutral gray gradient was laid down as the background. The pilot was then "pasted" on the mask to separate him from the background. The plane was adjusted in Macromedia's Swivel 3-D for scale, color, lighting, and positioning. Ribbons were drawn using the pen tool in Photoshop.

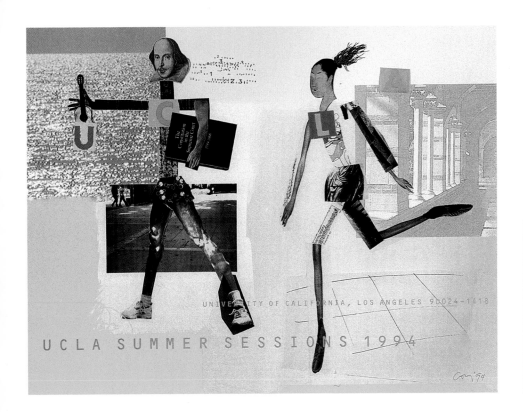

Design Firm COY, Los Angeles
Designer John Coy, Albert Choi
Art Director John Coy
Illustrator John Coy
Hardware Macintosh IIci, 20M RAM, 80MB internal
Software Adobe Photoshop 2.5.1, QuarkXPress 3.3
Client U.C.L.A. Extension School

This design was created to attract students to U.C.L.A.'s summer session. Images of running figures were collaged outside of the computer, and scanned and merged within a photographic collage background. Next, the designers created painterly additions in Adobe Photoshop, while maintaining a hand-collaged quality.

Design Firm COY, Los Angeles
Designer John Coy
Art Director John Coy
Hardware Macintosh IIci, 20M RAM, 80M internal
Software Adobe Photoshop 2.5.1
Client Pieces

This design was created to complement the chic and playful furniture creations of Dean Hackett. The logo is made of manipulated, cropped, and merged photography, and was created completely within Adobe Photoshop.

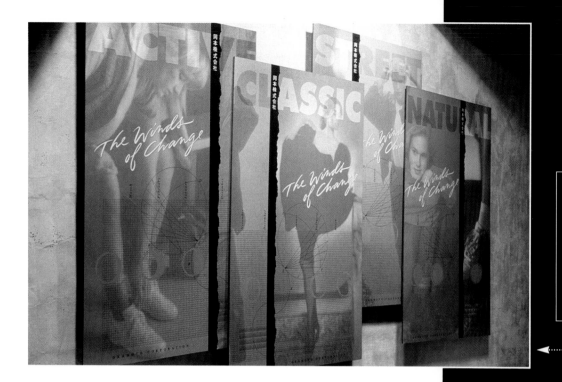

Design Firm Hornall Anderson Design Works
Designers John Hornall, Julie Lock,
 Mary Hermes, Julie Keenan
Art Director John Hornall
Hardware Power Macintosh 8100 72/1000
Software Adobe Photoshop, Aldus FreeHand
Client Okamoto Corporation

The objective for this piece was to create a design that would promote the client as an innovator in the industry. Images were scanned and color-manipulated in-house and the posters were output directly from computer disks.

Design Firm Hornall Anderson Design Works
Designers John Hornall, Julia LaPine, Heidi Favour
Art Director John Hornall
Photographers Robin Bartholick, Jeff Zaruba,
 Dan Freeman
Hardware Power Macintosh 8100 72/1000
Software QuarkXPress, Aldus FreeHand
Client Airborne Express

The main challenge in designing this annual report was including airplane elements in the image. Designers photographed a paper collage, which was merged in Photoshop with an existing shot of clouds. The collage image was then scanned as a 4-color process and the clouds were reproduced as a quadtone. The shadow on the airplane was later added in Photoshop.

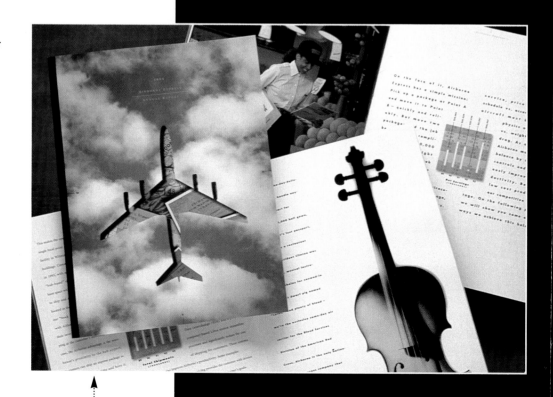

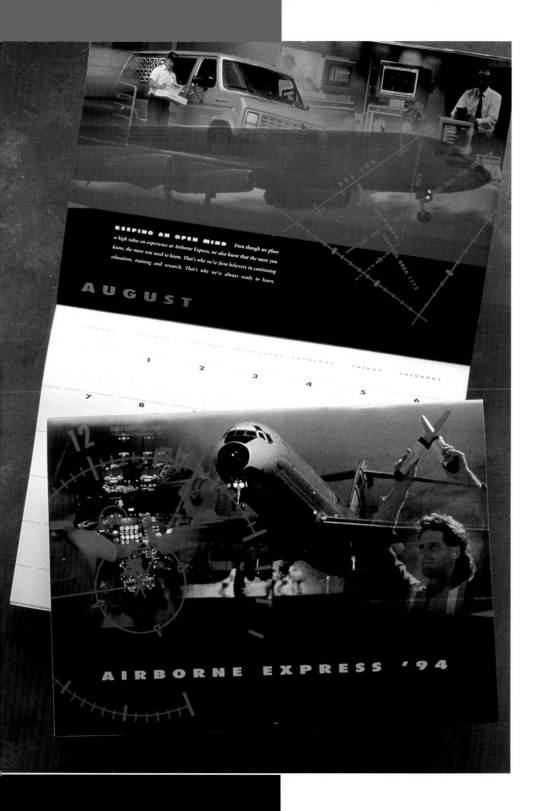

AIRBORNE EXPRESS '94

Design Firm Hornall Anderson Design Works
Designers John Hornall, Heidi Favour,
 John Anicker, Mary Chin Hutchinson
Art Director John Hornall
Photographer Jeff Zaruba
Hardware Power Macintosh 8100 72/1000
Software Aldus FreeHand, Adobe Photoshop
Client Airborne Express

This calendar design used stock photographs in an interesting way: Several images were combined to make one prominent layout. The photographer projected three or four slides of individual images, took Polaroid photographs of the projections, and used these photos as a map to merge the actual stock photographs in Photoshop.

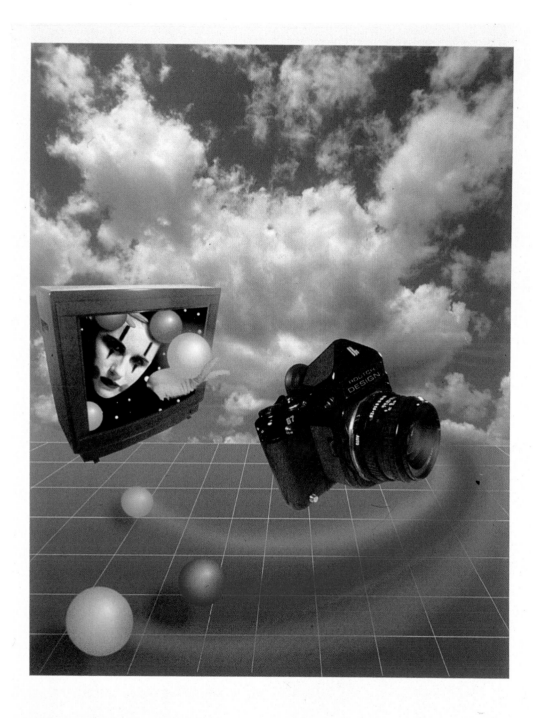

Design Firm Raging Pixels/Routch Design
Designer Monique Saner
Art Director Monique Saner
Illustrator Michael Brennan
Photographer Michael Brennan
Hardware 486 DX, Targa Card
Software HiRes QFX
Client Self-Promotion

This image was produced to visually depict what the designers do. It is a composite of five slides and computer artwork. The type in the firm's logo was created to look like Pentax type with the same texture. The computer allowed designers to alter and combine images.

Design Firm Imaginings Computer Graphics
Designer Gene R. Edwards
Photographer Gene R. Edwards
Hardware Amiga 1000
Software DigiView, Pixmate, DeluxePaint

The designer made this photo of a cloudy sky into a surreal landscape by reducing the number of colors in the image, manipulating the color palette, and using the entire image as a brush for stamping and simulated spray-painting.

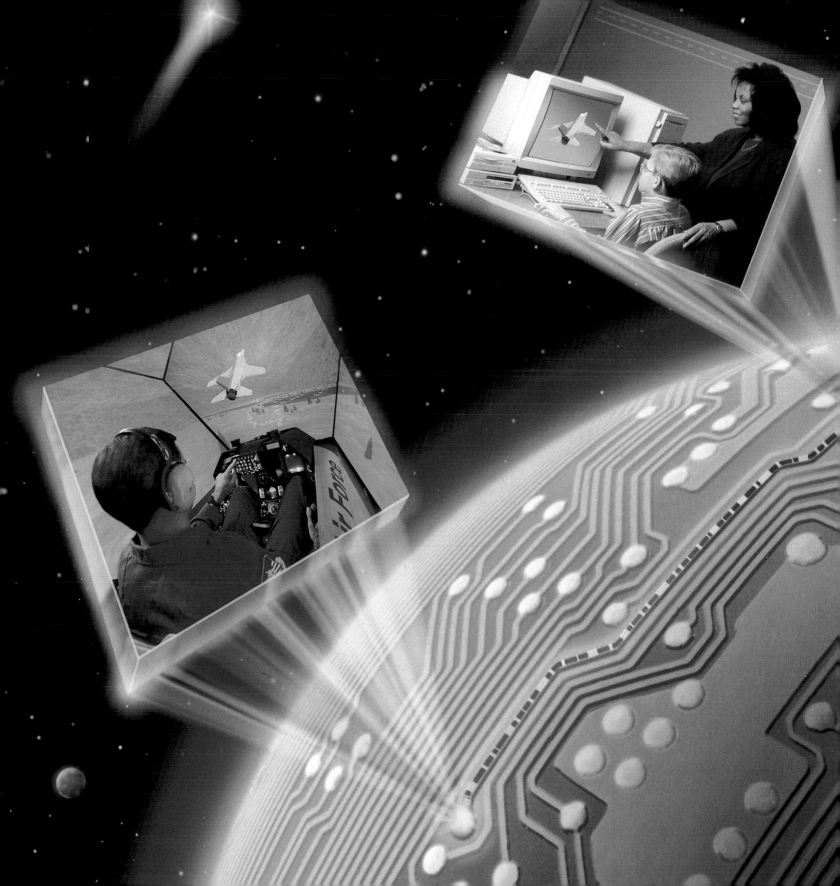

Design Firm Research Communications Center
All Design Brian Watkins
Photographer Brian Watkins
Hardware Quadra 950. 72M RAM. Leafscan 45
Software Adobe Photoshop 2.5. Adobe Illustrator
Client Armstrong Laboratory

The goal of this photo-illustration was to demon-
strate the client's capabilities in transferring technol-
ogy from defense-related training to civilian training.
A significant number of channel masks were
required to composite this image in a reasonably
seamless manner.

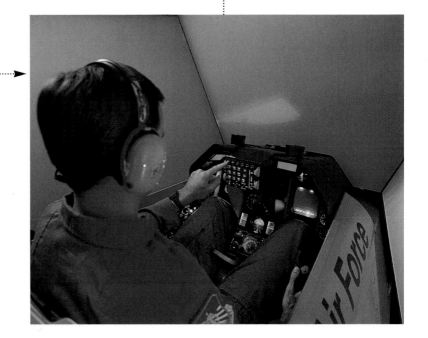

SyncMaster GL and GLs Monitors have all the features you're looking for.

SAMSUNG
ELECTRONICS

Design Firm Mike Quon Design Office
Designers Mike Quon, Erick Kuo
Art Director Mike Quon
Illustrators Mike Quon, Erick Kuo
Hardware Quadra 800
Software Adobe Illustrator 5.0, QuarkXPress 3.3
Client Samsung

Perfect for every environment SyncMaster GL and GLs Monitors

ELECTRONICS

The concept for this poster was to represent the product's flexibility for users by combining a realistic photo with a hard-edge graphic. The challenge was to control the Photoshop file (TIFF) and postscript file so that they both reached the same resolution quality for printing.

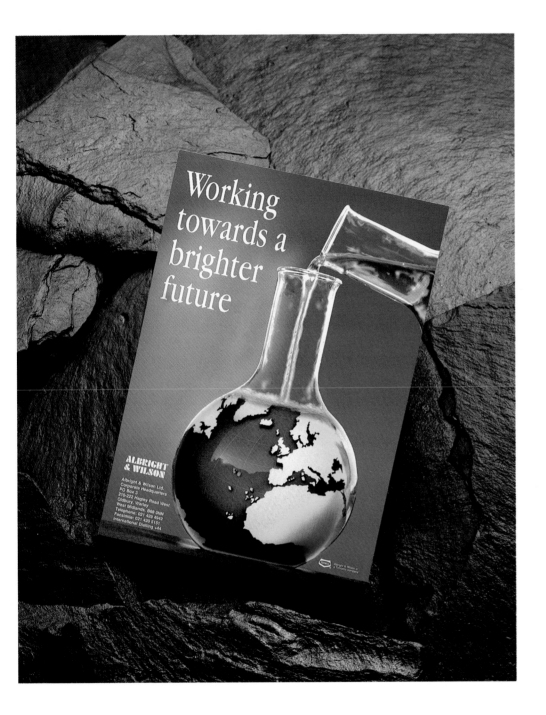

Design Firm Michael Davighi Associates Limited
Designer Pushpinder Ropra
Art Director Michael Davighi
Illustrators Michael Bevan, Barhat Patel
Photographer Michael Davighi
Hardware Macintosh
Software Adobe Photoshop 3.0
Client Albright & Wilson UK Limited

This advertisement was designed to project a professional image of an international chemical company. A back-lit photograph of flasks and water was taken against a dark background to heighten the dramatic effect, and the illustration of the world was created as flat artwork. Both images were scanned into the system in high resolution, merged using Photoshop, and manipulated. The background color was changed to sky blue, and the reflections in the glass were retained.

51

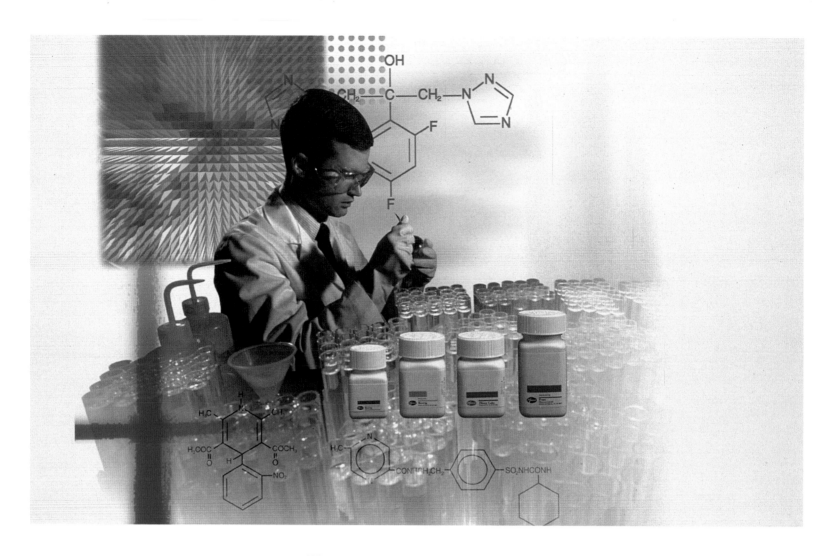

Design Firm O & J Design, Inc.
Designer Inhi Clara Kim
Art Director Andrzej Olejniczak
Hardware Macintosh Quadra 800
Software Adobe Photoshop, Adobe Illustrator
Client Pfizer

Using photographs chosen from Pfizer's archive, the objective was to create a collage that imitated the look and feel of hand-drawn illustrations in Pfizer's annual report. The final collage, which was output directly to a 4- by 5-inch chrome, was reproduced for a trade show exhibition panel.

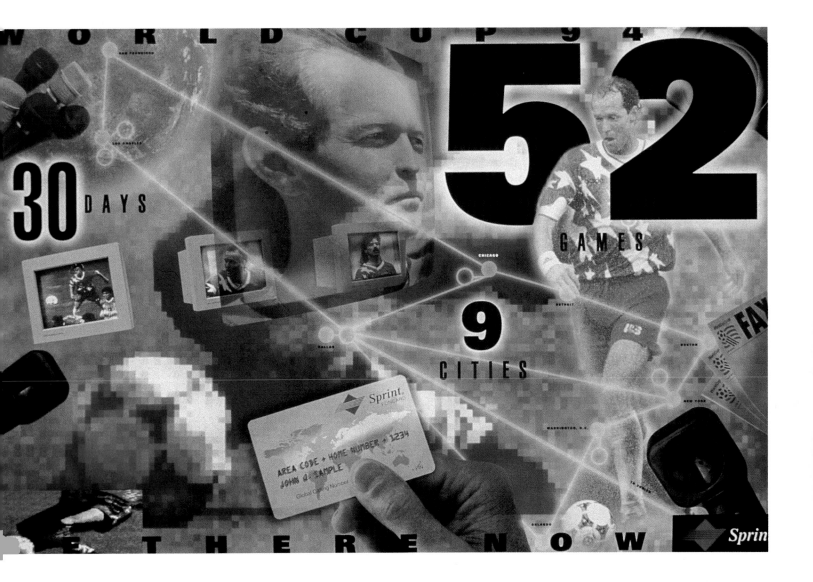

Design Firm Muller + Company
Designer Scott Chapman
Art Director John Muller
Photographer Mike Regnier
Hardware Macintosh
Software Adobe Photoshop.
 Adobe Illustrator, QuarkXpress
Client Sprint

This design was intended to communicate Sprint's commitment to both World Cup soccer and leading-edge technology. Two original transparencies were sandwiched together and scanned as a single image. A low-resolution image was imported into Illustrator to generate the large type. Type vignettes were created in Photoshop along with additional color correction and general retouching. The body copy was set in QuarkXPress.

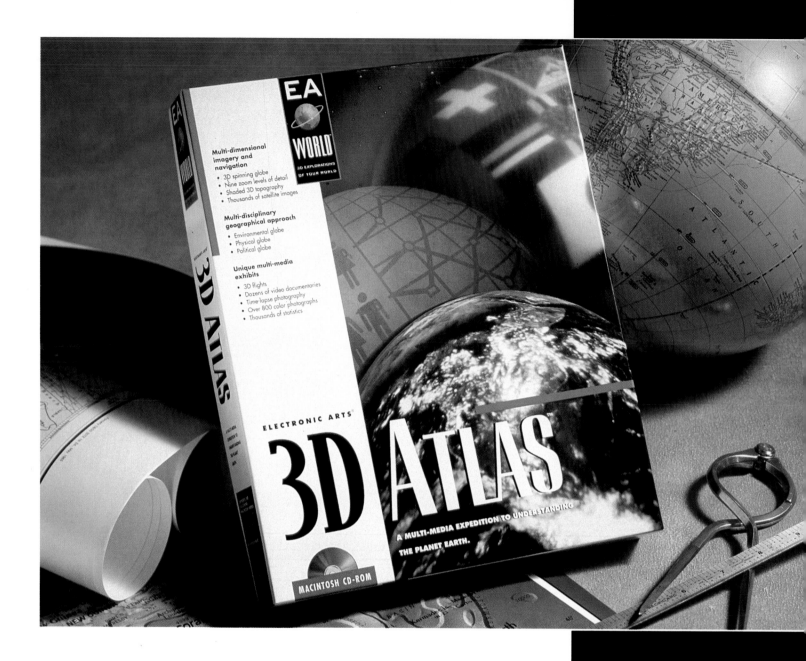

Design Firm Jamie Davison Design, Inc.
Designer David Trujillo-Farley
Art Director Jamie Davison
Illustrator David Trujillo-Farley
Photographer R. J. Muna
Hardware Macintosh Power PC 7100, Sony 17"
 Multiscan HG, PLI 44M Syquest drive
Software Adobe Photoshop, Andromida 3-D
Client Electronic Arts

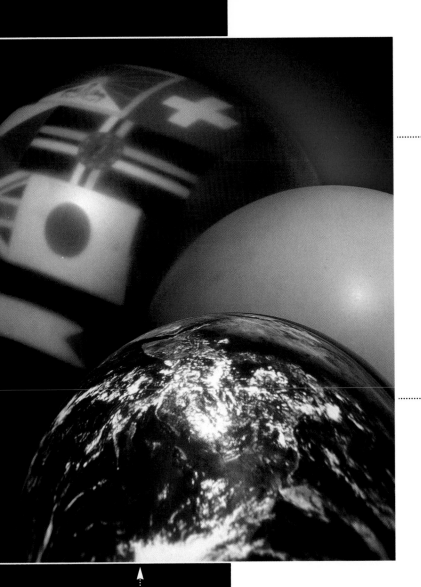

For this package illustration, designers created a cigar box-like seal containing the brand name and featuring a bright, three-dimensional image of the earth orbited by a yellow rule simulating the earth's rotation. Other digitally created imagery includes an aerial view of the earth, supplied by NASA and projected onto the globe in the package foreground.

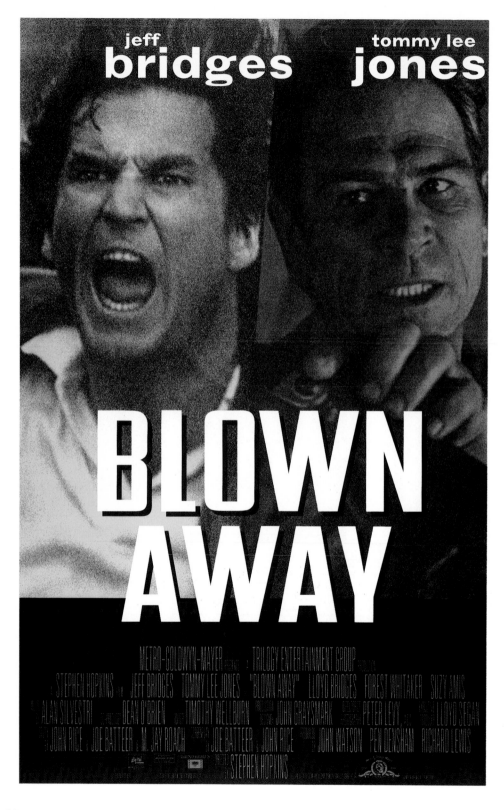

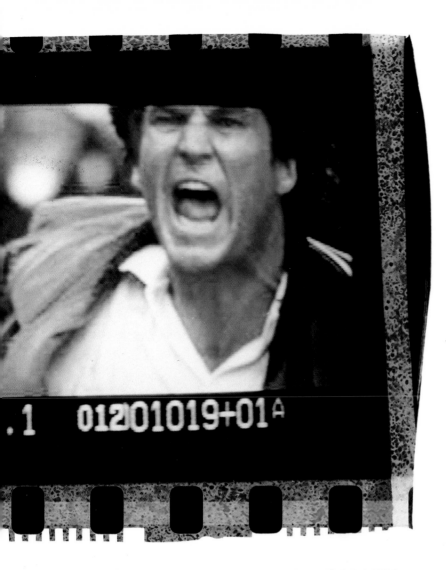

Design Firm Mike Salisbury Communications
Designer Mike Salisbury
Art Director Mike Salisbury
Illustrator Alan Williams
Photographer Bruce Birmalin
Hardware Macintosh
Software Adobe Photoshop
Client MGM

.1 01201019+01ᴬ

For this movie poster image, Jeff Bridges' entire face had to be constructed and created in the computer from various photos and film clips. Tommy Lee Jones' face was enhanced and balanced to match the size of Jeff's, and his hand was moved up to fit the layout. None of this could have been created as effectively by hand.

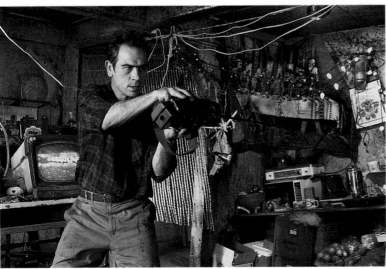

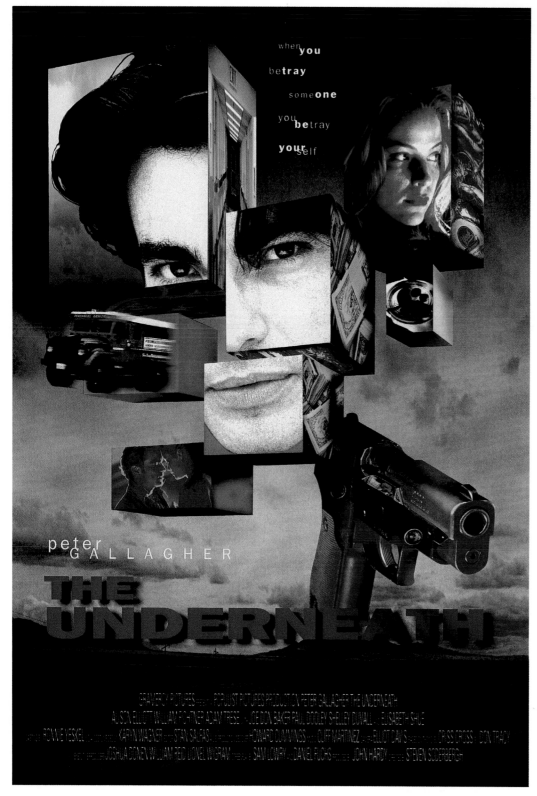

when **you** be**tray** some**one** you be**tray** **your** self

peter GALLAGHER

THE UNDERNEATH

Design Firm Mike Salisbury Communications
Designer Mike Salisbury
Art Director Mike Salisbury
Illustrator Ron Brown
Photographer Allan Pappe
Hardware Macintosh
Software Adobe Photoshop
Client Gramercy

The background, cube, double exposure of the car on the gun, the title, sky, and other graphic effects all could have been done by hand, but only with greatly added expense and labor. Using the computer, designers were able to do all of this economically, and were also able to test images of all design effects.

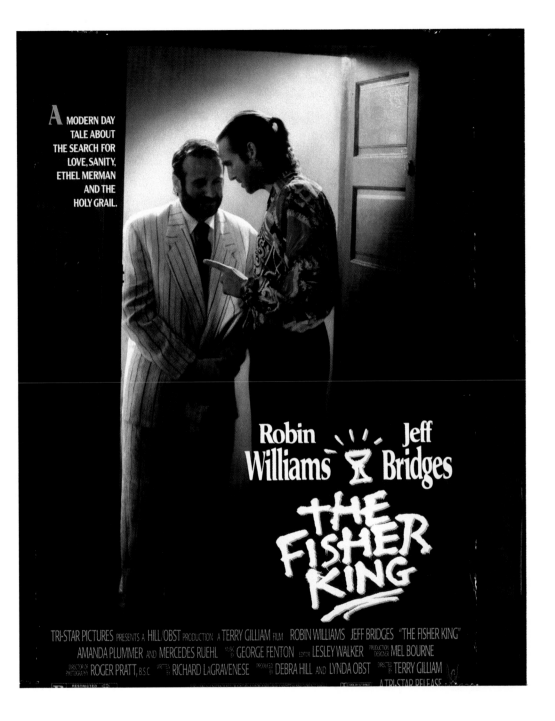

A MODERN DAY TALE ABOUT THE SEARCH FOR LOVE, SANITY, ETHEL MERMAN AND THE HOLY GRAIL.

Robin Williams ⚭ Jeff Bridges

THE FISHER KING

TRI-STAR PICTURES PRESENTS A HILL/OBST PRODUCTION A TERRY GILLIAM FILM ROBIN WILLIAMS JEFF BRIDGES "THE FISHER KING" AMANDA PLUMMER AND MERCEDES RUEHL MUSIC BY GEORGE FENTON EDITOR LESLEY WALKER PRODUCTION DESIGNER MEL BOURNE DIRECTOR OF PHOTOGRAPHY ROGER PRATT, B.S.C. WRITTEN BY RICHARD LaGRAVENESE PRODUCED BY DEBRA HILL AND LYNDA OBST DIRECTED BY TERRY GILLIAM A TRI-STAR RELEASE

RESTRICTED

Design Firm Mike Salisbury Communications
Designer Mike Salisbury
Art Director Mike Salisbury
Illustrator Digital Trans Graphics
Photographer Film clip from a motion picture
Hardware SUPERSET
Software Propriority SUPERSET
Client Tri-Star

This picture, taken from a motion-picture film frame, was grainy, soft, and lacked detail. Designers pushed in on the faces and created eyes in the face of Robin Williams. For the background, designers removed, by computer, the furniture and added lighting effects: none of this work could have been done by hand, as the detail was too small.

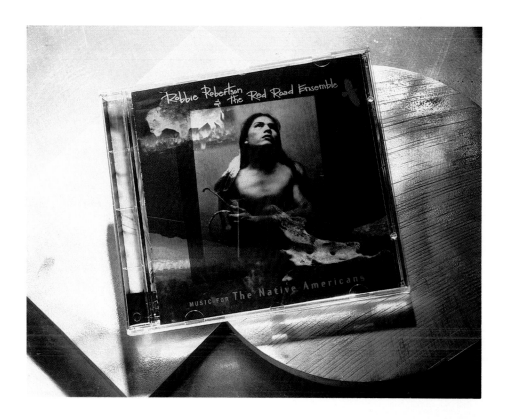

Design Firm COY, Los Angeles
Designers John Coy, David Jordan Williams
Art Director John Coy
Hardware Macintosh IIci, 20M RAM, 80M
 internal hard drive, 540M external hard drive,
 21" Agfa Arcus flatbed scanner
Software Adobe Photoshop 2.5.1, QuarkXPress 3.3
Client Capitol Records

The design for this CD package portrays the tension between traditional Native American ways of life and contemporary, mainstream society. Graphics for the package were scanned, collaged, and color corrected in-house.

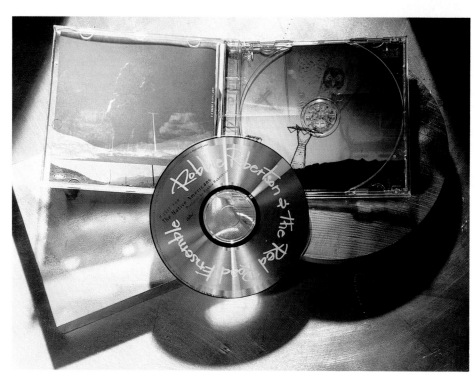

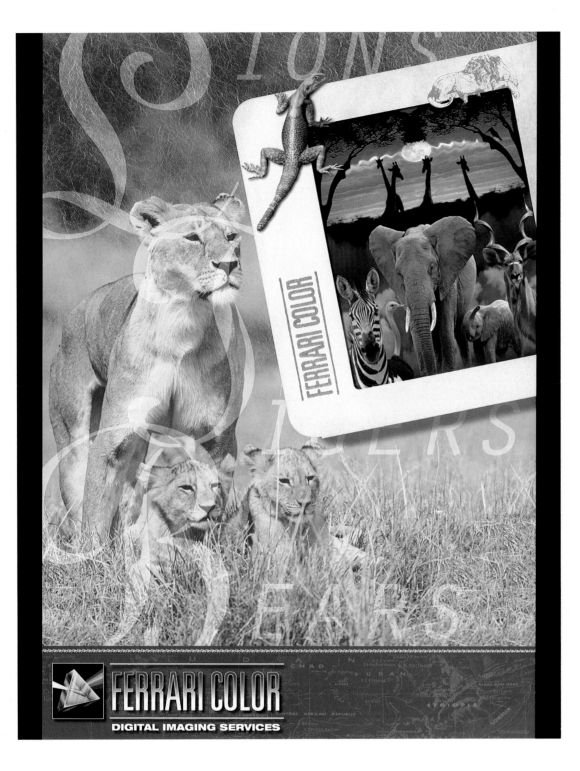

Design Firm Ferrari Color
Designer William Semo
Art Director William Semo
Illustrator William Semo
Photographer Judy Whitcomb
Hardware Macintosh Quadra 950,
 Somet 455, LVT Saturn 1010
Software Adobe Photoshop,
 Adobe Illustrator
Client Ferrari Color

This design demonstrates to clients how 15 separate images can be joined digitally to create a single, seamless picture. Designers included traditional 35mm photographs, manipulated through the computer, to show the design field's link to and evolution from traditional photography.

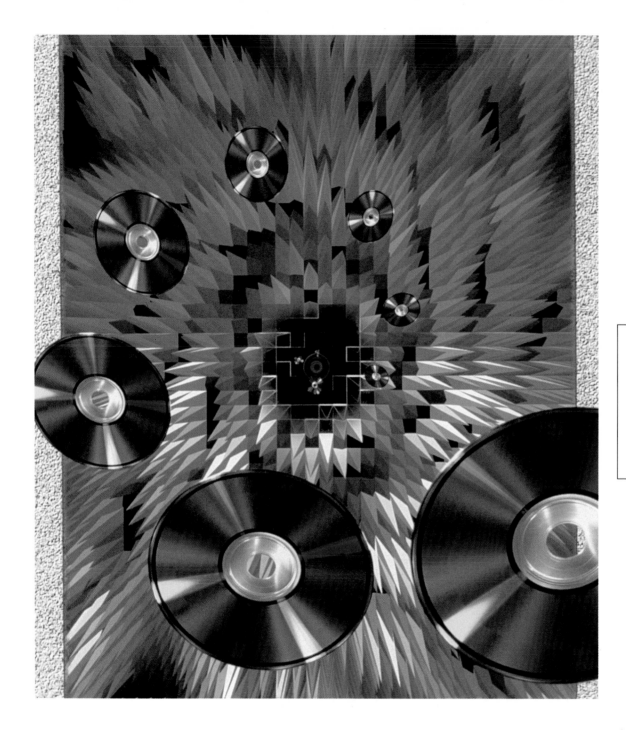

Design Firm Larry Hamill Photography
All Design Larry Hamill
Hardware Macintosh
Software Adobe Photoshop 2.51,
 KPT Bryce

For this image, the flying
compact disks were textured
with KPT Bryce and embossed
in Photoshop. The extruding
pyramids were then pasted
onto the image of the CDs.

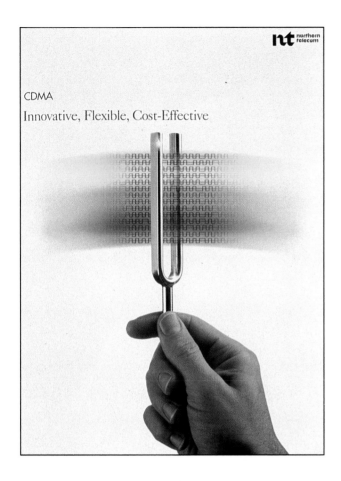

CDMA

Innovative, Flexible, Cost-Effective

Design Firm Peterson & Company
Designer Dave Eliason
Art Director Dave Eliason
Illustrator Russ Windstrand
Photographer Russ Windstrand
Hardware Power Macintosh
Software Adobe Photoshop
Client Northern Telecom

This image is designed to portray the high quality of sound attainable through the use of this product. Since digital codes are an integral part of the product, they are shown at the center of the tuning fork. The modified rainbow arc, the relative transparency of the image, and sizing and assembly were all achieved through Photoshop.

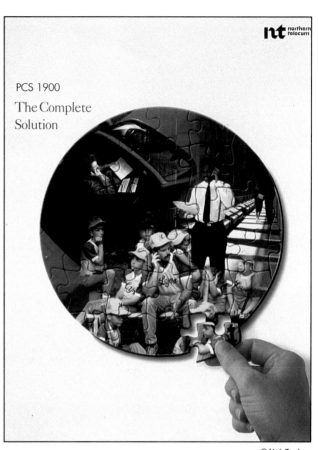

PCS 1900

The Complete
Solution

©J.W. Burkey.

Design Firm Peterson & Company
Designer Dave Eliason
Art Director Dave Eliason
Photographer J. W. Burkey
Hardware Macintosh
Software Adobe Photoshop
Client Northern Telecom

This design was achieved by combining several different images with the outlines of actual puzzle pieces. It took several rounds of revision to get just the right highlights and shadows in the crevices.

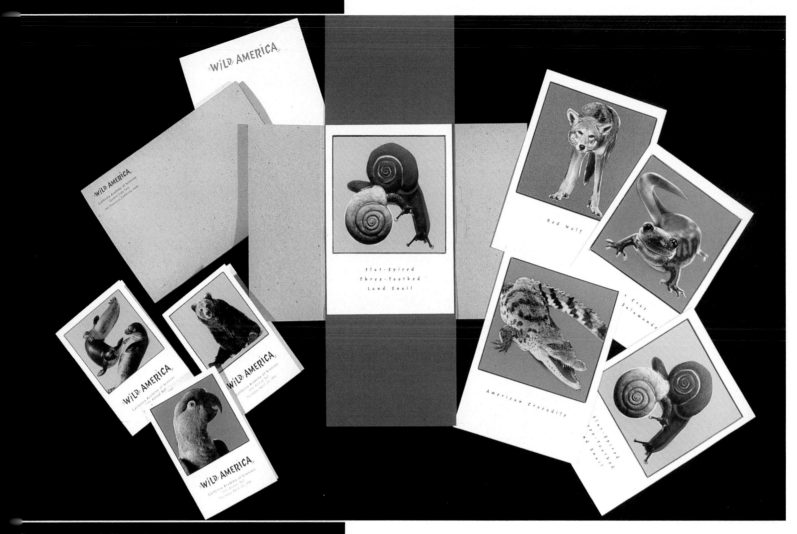

Design Firm Kiku Obata & Company
Designer Amy Knopf
Art Director Amy Knopf
Photo Color Designer Amy Knopf
Photographers Susan Middleton, Dave Liittschwager
Hardware Macintosh Centris 660
Software Adobe Photoshop, Adobe Illustrator,
 QuarkXPress
Client California Academy of Sciences

The designer added color to the photos using flat colors rather than process colors because Photoshop automatically converts all flat colors to process. Photos were opened in Photoshop and filters were applied, then both were placed in Illustrator for color application.

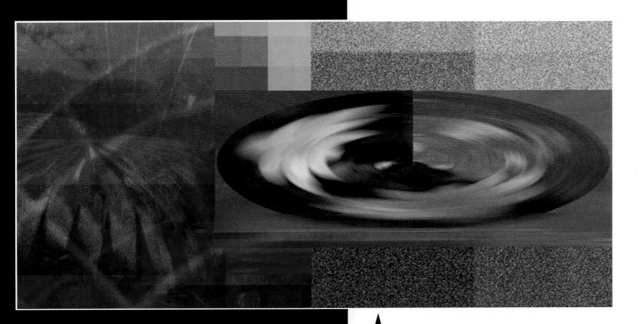

For this piece, a photograph of a fern was transformed with color and additional stylistic filters. The flower was given a spiral effect by using the polar coordinates filter.

Design Firm Beth Santos Design
All Design Beth Santos
Hardware Macintosh Quadra 650. UMAX scanner
Software Adobe Photoshop

Several photographs were manipulated with color. stylistic filters, and varying degrees of opacity to create a collage effect, for the final image.

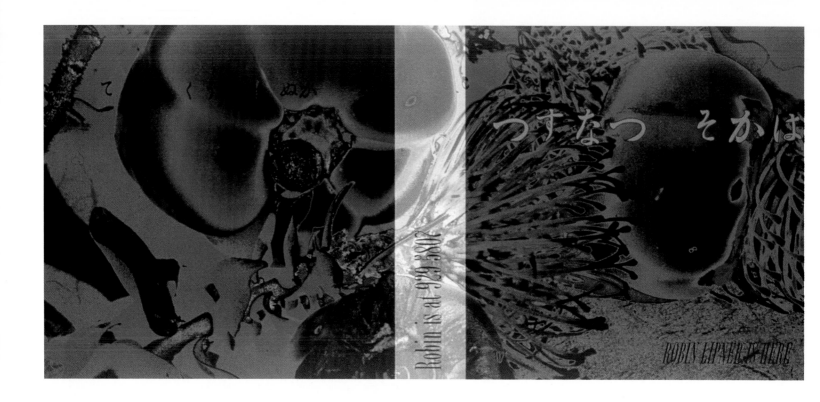

つすなつ　そかは

Robin is at 929 3802

ROBIN LIPNER DIGITAL

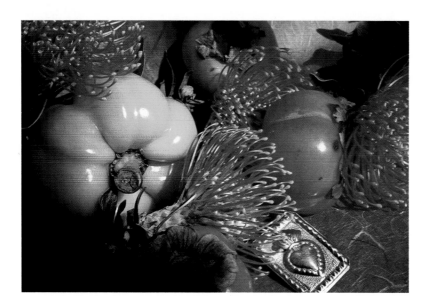

Design Firm Robin Lipner Digital
All Design Robin Lipner
Hardware Macintosh Quadra 840 AV. UMAX scanner
Software Adobe Photoshop

The original photograph was scanned into the computer and manipulated with the "invert" and "solarize" tools. The color distortion was completed globally from image processing in Photoshop.

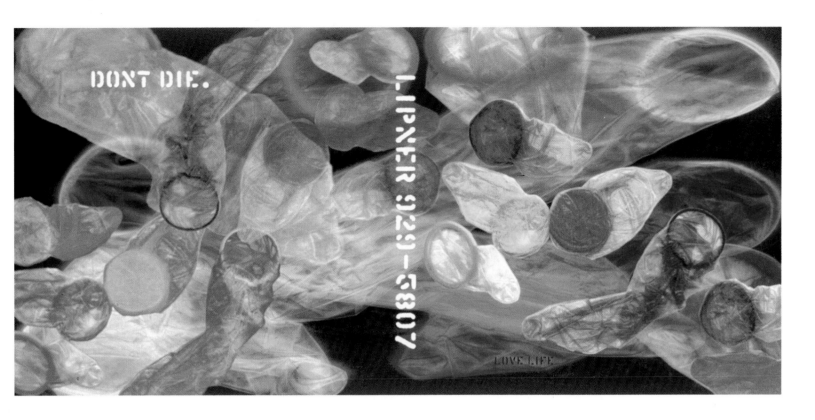

DONT DIE.

LIPNER 929-5807

LOVE LIFE

Design Firm Robin Lipner Digital
All Design Robin Lipner
Hardware Macintosh Quadra 840 AV. UMAX scanner
Software Adobe Photoshop

Objects were scanned directly on the flatbed scanner. Portions of the image were inverted, and the contrast was altered to heighten color. The color choices available on the computer allowed the designer easier and faster experimentation than traditional painting or darkroom techniques.

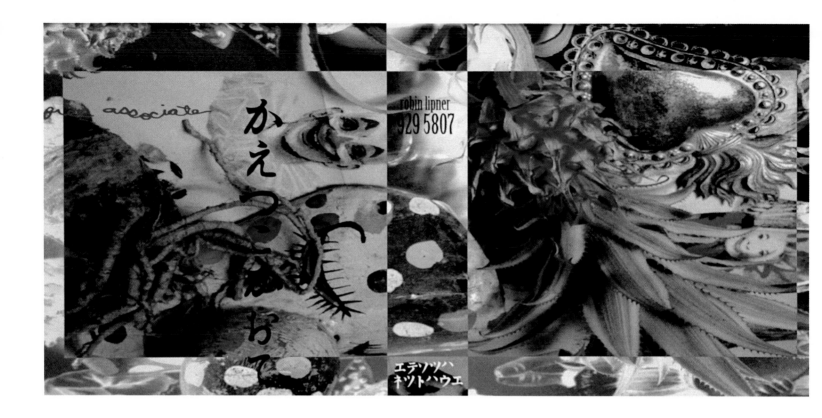

robin lipner
929 5807

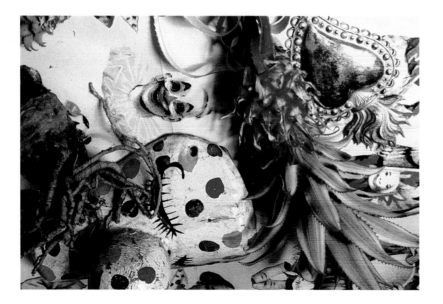

Design Firm Robin Lipner Digital
All Design Robin Lipner
Hardware Macintosh Quadra 840 AV. UMAX scanner
Software Adobe Photoshop

This self-promotion piece. "Free Association." began as a scanned photograph. The image was then distorted by nonproportional scaling. inverted. and accented with Japanese characters.

Design Firm Robin Lipner Digital
All Design Robin Lipner
Hardware Macintosh Quadra 840 AV. UMAX scanner
Software Adobe Photoshop

Two photographs, sky and ferns, were scanned into the computer and merged in Photoshop. This straight blend was developed with the use of different levels of opacity.

For this piece, a photograph of a knotted tree was merged with an image of clouds and sky. In Photoshop, the designer selected the root portion of the tree image and pasted it into the sky background with varying degrees of opacity.

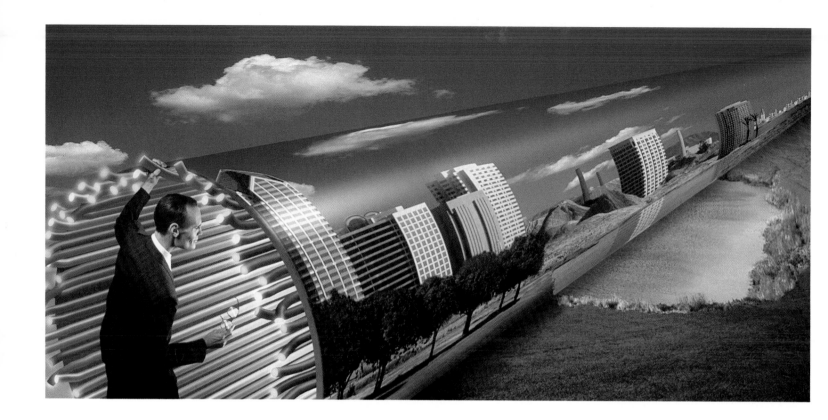

Design Firm McCann Erikson, R/GA Digital Studios
Art Director Deborah Yaffe
Digital Design R/GA Print
2-D, 3-D Animation R/GA Print
Photographer Ryszard Horowitz
Hardware Macintosh. Silicon Graphics workstation
Software Imrender. Adobe Photoshop, SoftImage
Client AT&T Bell Laboratories

This advertisement was created using R/GA's custom-written three-dimensional graphics software. The cityscape, the large tube, and the smaller fiber-optic inner tubes were digitally manipulated and composited with the photograph of the man in the foreground.

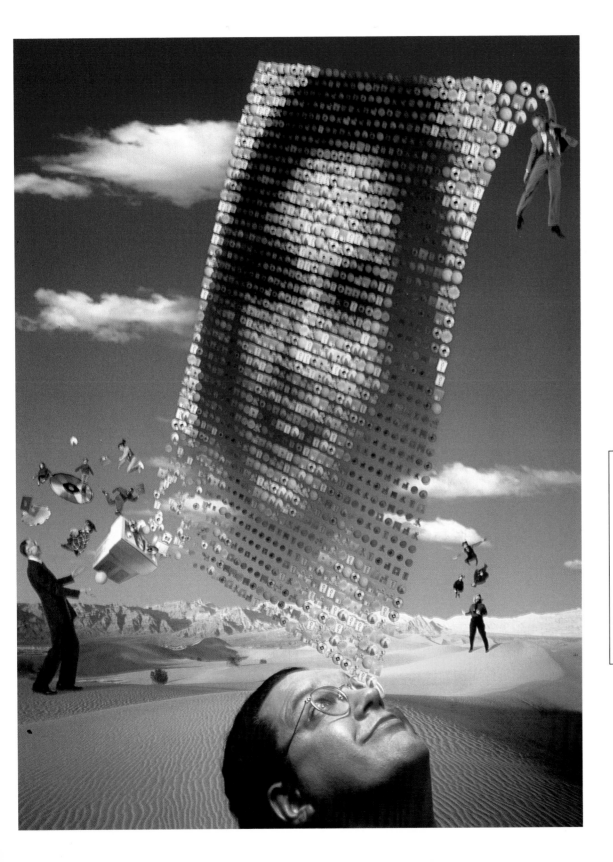

Design Firm R/GA Digital Studios
Art Director Ilona Jones
Digital Design R/GA Print
2-D, 3-D Animation R/GA Print
Photographer Ryszard Horowitz
Hardware Macintosh. Silicon
 Graphics workstation
Software Imrender. Adobe
 Photoshop
Client AT&T Bell Laboratories

This face image was created with scanned images of compact disks and computer equipment. Designers distorted the original photographs, both the facial component and the background, in Photoshop and Imrender.

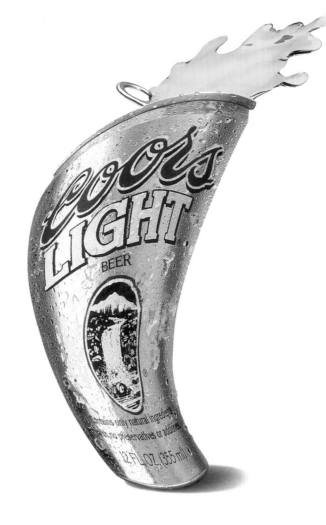

Design Firm Studio 212°
Designer David Nickel
Art Director David Nickel
Illustrator Studio 212°
Hardware Quantel Graphic Paintbox®
Software Quantel Graphic Paintbox®
Client Coors Light/The Integer GP

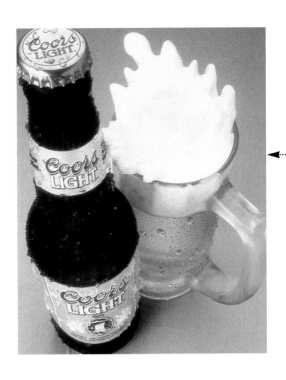

The extreme distortions to the beer can, beer mug, and beer bottle were achieved by using Quantel's contour package. Subtle illustration and color correction make the effect convincing.

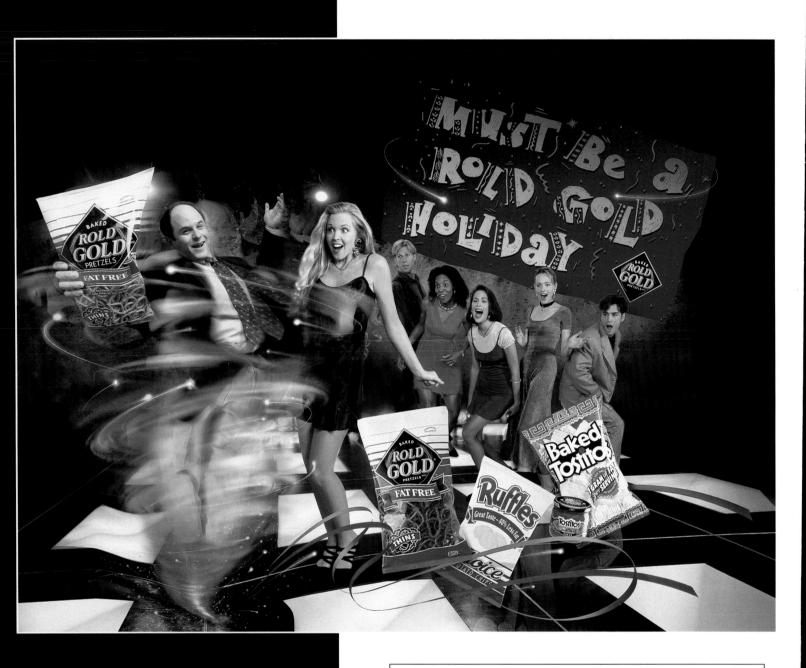

Design Firm Studio 212°
Designer Fred Gardner
Art Director Fred Gardner
Illustrator Studio 212°
Photographer Jay Silverman
Hardware Quantel Graphic Paintbox®
Software Quantel Graphic Paintbox®
Client Frito Lay

Models were all photographed separately and the images were placed on a photo of an empty dance floor. Distortions were accomplished using Quantel's contour package, and type was grabbed from an "illustrator" file. The tornado effect was then illustrated, packages were placed, and ribbons illustrated.

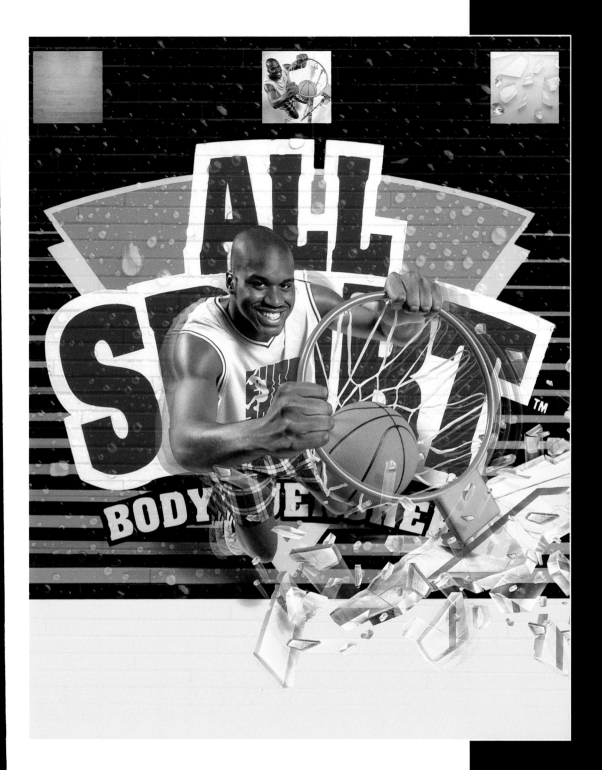

Design Firm Studio 212°
Designer Rob Reed
Art Directors Rob Reed. Tom Collins
Illustrator Studio 212°
Hardware Quantel Graphic Paintbox®
Software Quantel Graphic Paintbox®
Client All Sport/BBD Needham

This image of basketball star Shaquille O'Neal was made from a 35mm transparency and heavily retouched to sharpen the figure. The entire background and all gloss charts were illustrated. including shadows and movement lines.

Design Firm Animus Comunicaçáo
Designer Rique Nitzsche
Art Director Rique Nitzsche
Computer Operator Levindo Carneiro
Photographer Al Hamdan
Hardware Adobe Photoshop
Software Macintosh Quadra 950
Client Maguary

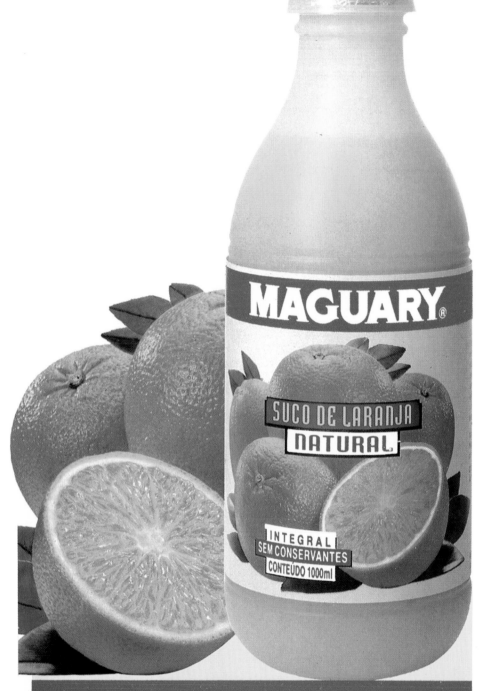

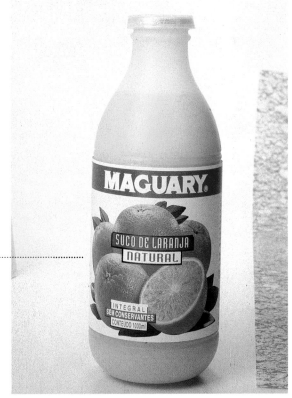

Designers created this Brazilian orange juice bottle label in a very short time. Since the Brazilian orange was out of season at the time of design, artists manipulated a photograph of a Florida orange by superimposing a cut Brazilian orange that had been shot in identical light. Both photos were then mixed with the computer.

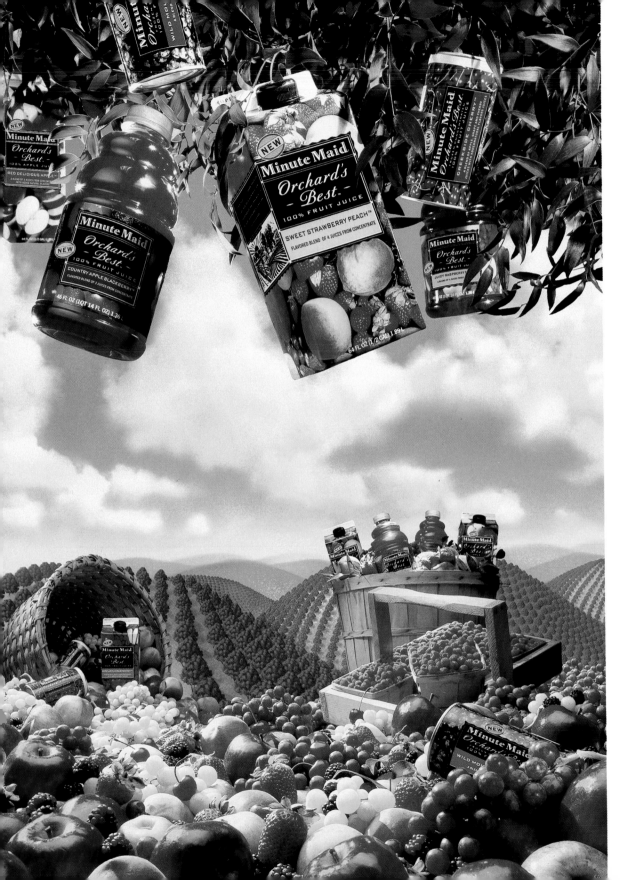

Design Firm Studio 212°
Designer Mark Sullivan
Art Director Mark Sullivan
Illustrator Studio 212°
Photographer David Chasey
Hardware Quantel Graphic Paintbox®
Software Quantel Graphic Paintbox®
Client Minute Maid

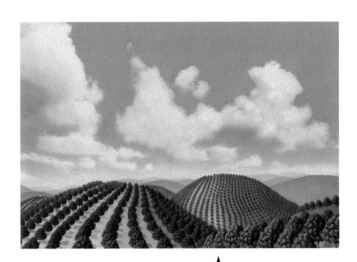

The initial illustration for this fruit juice advertisement was created on computer from pencil level drawings end-merged with photographs. The photos were then retouched and color-corrected on the same computer. The effect is that both exist convincingly within the same space.

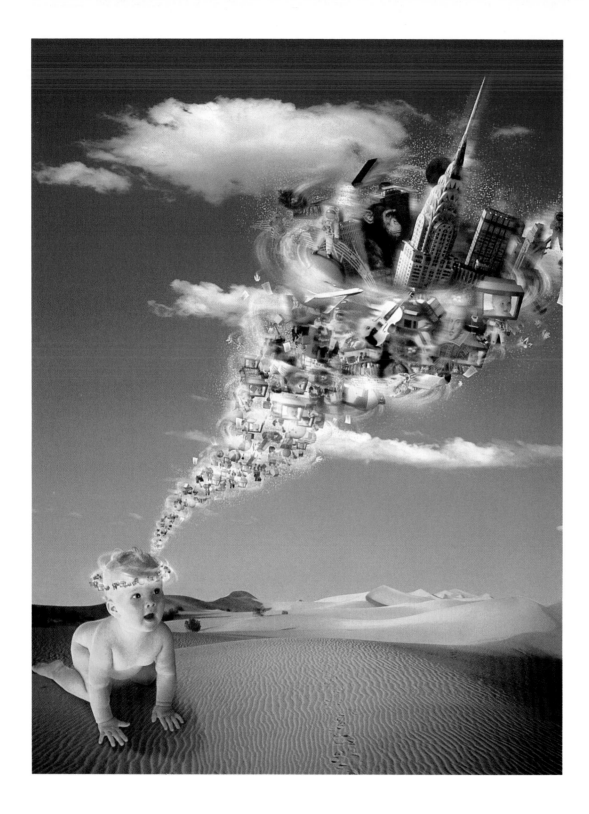

Design Firm R/GA Digital Studios
Art Director Anestos Tritchonis, CME
Digital Design R/GA Print
2-D, 3-D Animation R/GA Print
Photographer Ryszard Horowitz
Hardware Macintosh, Silicon Graphics
 workstation
Software Imrender, Adobe Photoshop
Client 3M

The spiral-blurred effect in these scanned, still photographs was accomplished with Imrender. The shots of the baby and the background were then manipulated with computer-spun elements.

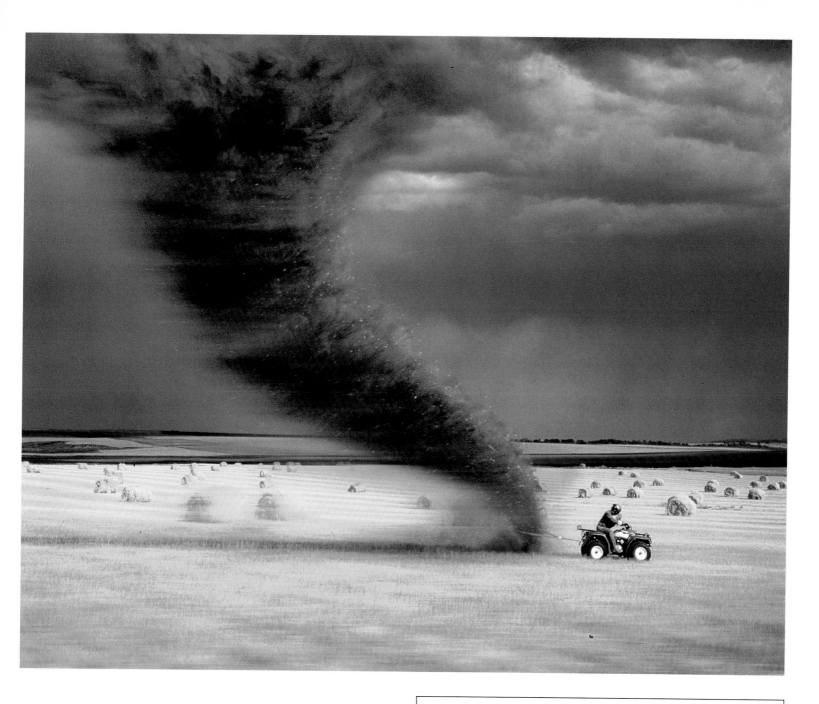

Design Firm Bozell, R/GA Digital Studios
Art Director M. Newhoff
Digital Design R/GA Print
2-D, 3-D Animation R/GA Print
Photographer Eric Meola
Hardware Macintosh, Silicon Graphics workstation
Software Imrender, Adobe Photoshop
Client Kawasaki

For this recent advertisement campaign, designers harnessed a tornado to a tractor by digitally combining photographic elements and backgrounds. Three-dimensional particle-systems' effects were added to create the twister's hay swirl.

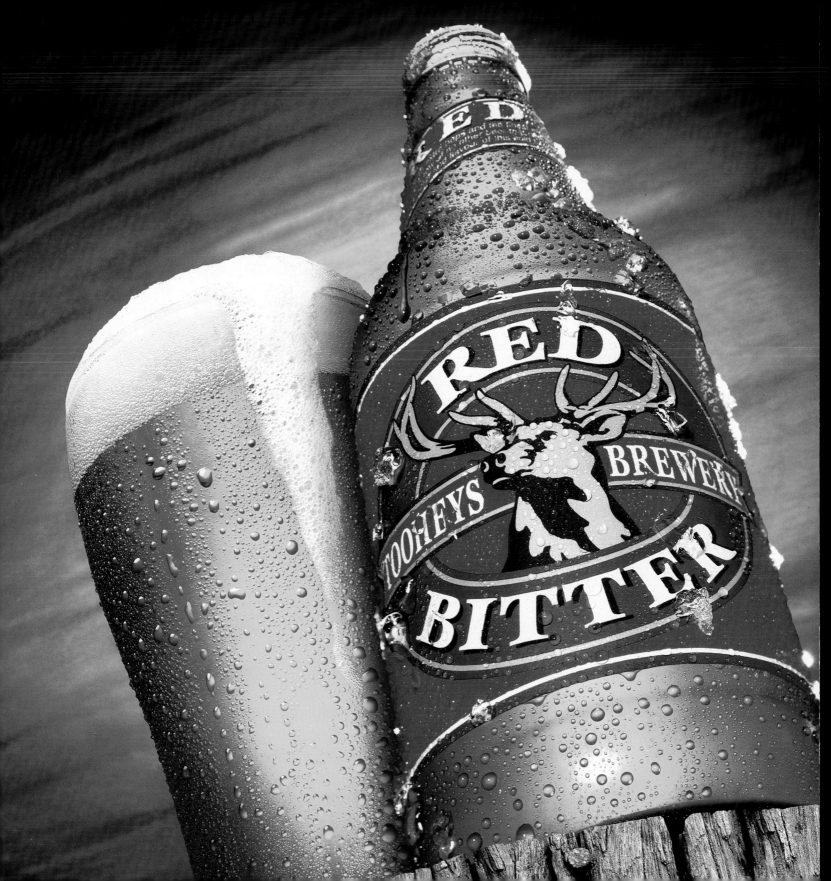

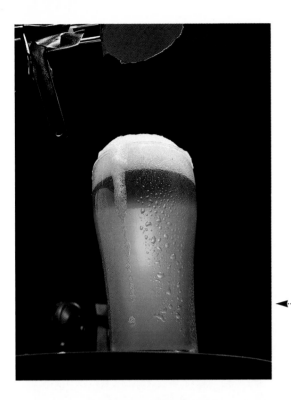

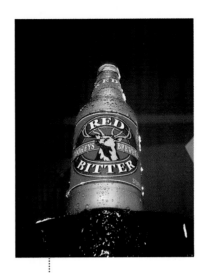

Design Firm Elton Ward Design & Photography
Designer Chris De Lisen
Art Directors Chris De Lisen, Steve Coleman
Photographer Andrew Kay
Hardware Quantel Graphic Paintbox®
Software Quantel Graphic Paintbox®,
 Adobe Photoshop
Client Tooheys Brewing Co., Ltd.

To save costs, layouts and early pre-production image composition were done in Photoshop on a Macintosh before final retouching was produced on a Quantel Graphic Paintbox®.

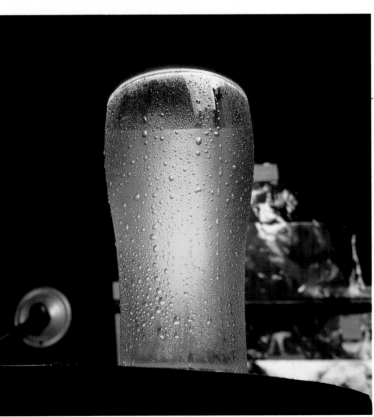

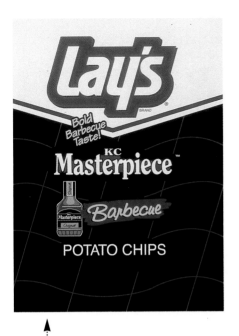

Design Firm Studio 212°
Designer Thai Nguyen
Art Director Thai Nguyen
Illustrator Studio 212°
Hardware Quantel Graphic Paintbox®
Software Quantel Graphic Paintbox®
Client Frito Lay

Photographs of wood were cloned to build the background of this advertisement; the bottle and branding iron were then put into position. The end of the iron and the wood brand were illustrated, as was the potato chip bag, which was minimally supplied on an "illustrator" file. Shadows were added to create a realistic space.

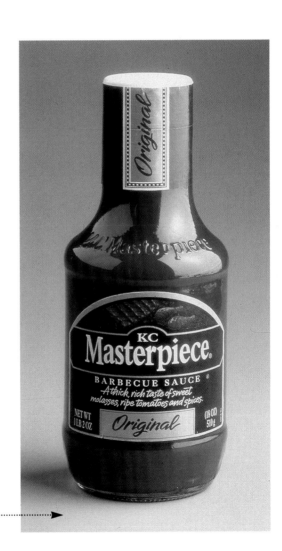

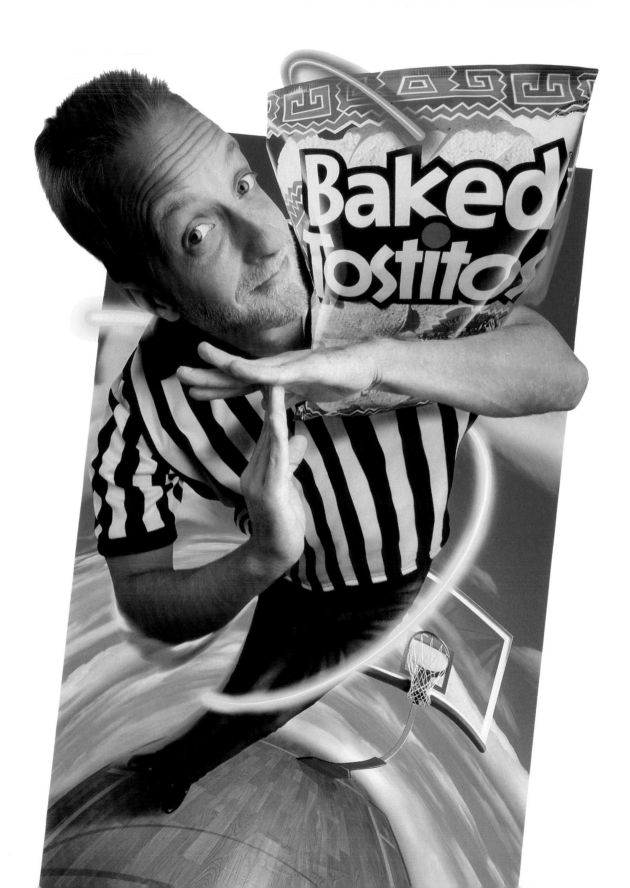

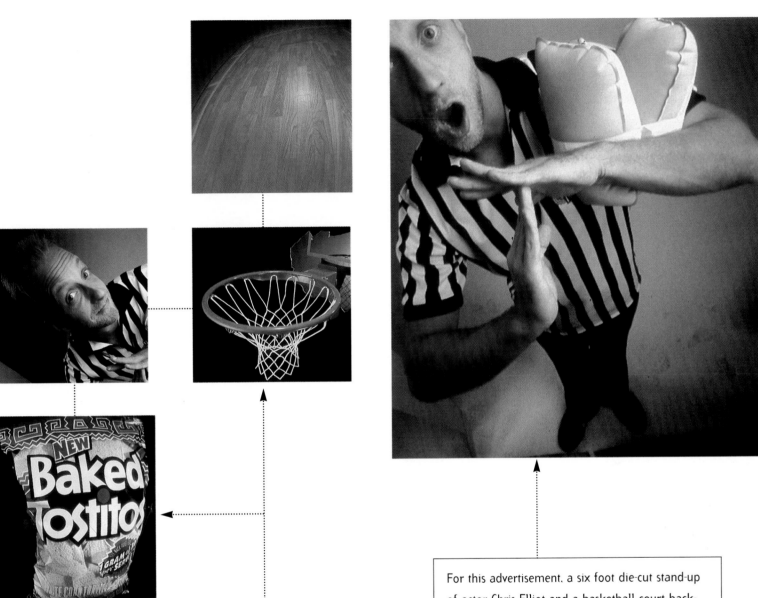

For this advertisement, a six foot die-cut stand-up of actor Chris Elliot and a basketball court background were distorted drastically using Quantel's contour software. Elliot's pants were illustrated on the computer.

Design Firm Studio 212°
Designers Thai Nguyen. Mike Apodoka
Art Directors Thai Nguyen. Mike Apodoka
Illustrator Studio 212°
Photographer Jay Silverman
Hardware Quantel Graphic Paintbox®
Software Quantel Graphic Paintbox®
Client Frito Lay/BBD Needham

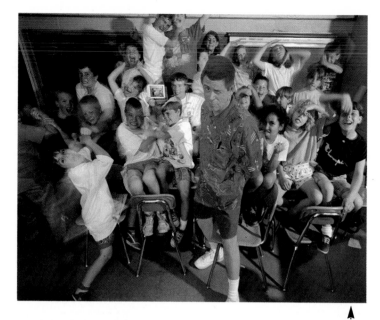

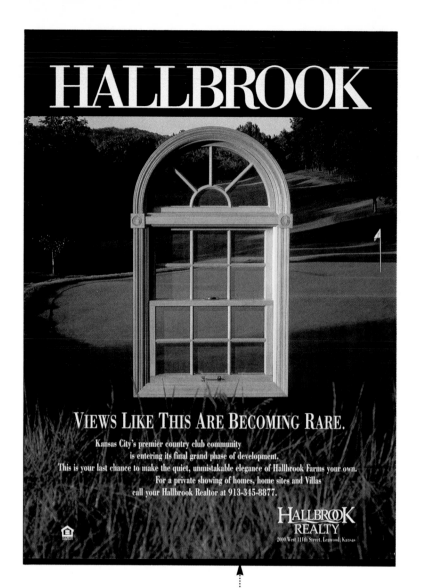

Design Firm Photo Design
All Design Jack McWilliams
Hardware Macintosh, Toyo View
Software Adobe Photoshop

The original photograph for this design was distorted to create a winking teacher leaning into the lens, without increasing his scale. Colorization aided in maintaining the relative size of the model.

Design Firm Muller + Company
Designer Charles M. Hoffman
Art Director Charles M. Hoffman
Illustrator Elise Ray
Photographer Steve Hix
Hardware Power Macintosh
Software Adobe Photoshop
Client Hallbrook

To create the floating window view, the photographer shot both the fairway and window at the same time—to capture the same mood and color of light. The two separate shots were then combined, and the window panes "knocked out" in order to match the fairway shot. Highlights were then added to give the illusion of glass.

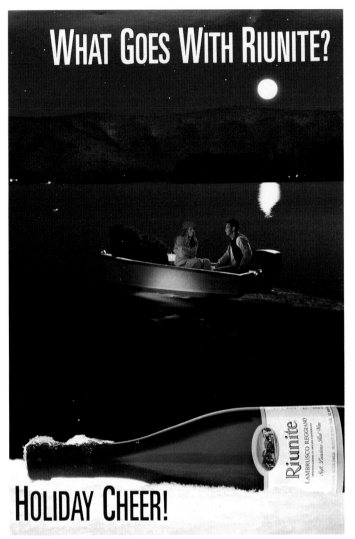

Design Firm Satterwhite Productions
Designer Joy Satterwhite
Art Director Craig Shaffer
Illustrator Joy Satterwhite
Photographer Al Satterwhite
Hardware Macintosh Quadra 950
Software Adobe Photoshop, Adobe Illustrator, QuarkXPress
Client Progress Printing

The layout of the calendar, rebuilding cover photo (from vertical to horizontal), molding type on rear cover, ghosting calendar over background image, and the construction of typeface were all done on the Macintosh Quadra 950.

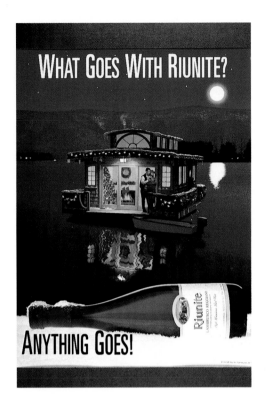

Design Firm Satterwhite Productions
Designer Joy Satterwhite
Art Director Lou LoPriore (Greenstone Roberts Div)
Illustrator Joy Satterwhite
Photographer Al Satterwhite
Hardware Macintosh Quadra 950, XL 7700, Syquest 88
Software Adobe Photoshop, Adobe Illustrator, QuarkXPress
Client Riunite

This large point-of-purchase advertisement used 35mm photography of an actual location, a miniature houseboat, real people, a fireplace fire, smoke, a boat wake, the moon and stars, and reflections. All elements were assembled in Photoshop; drawing with Illustrator incorporated a drum-scan background, Pro-DC input, and cool scan input. A 90 megabyte file was output from a magneto-optical disk to be sent to the printer.

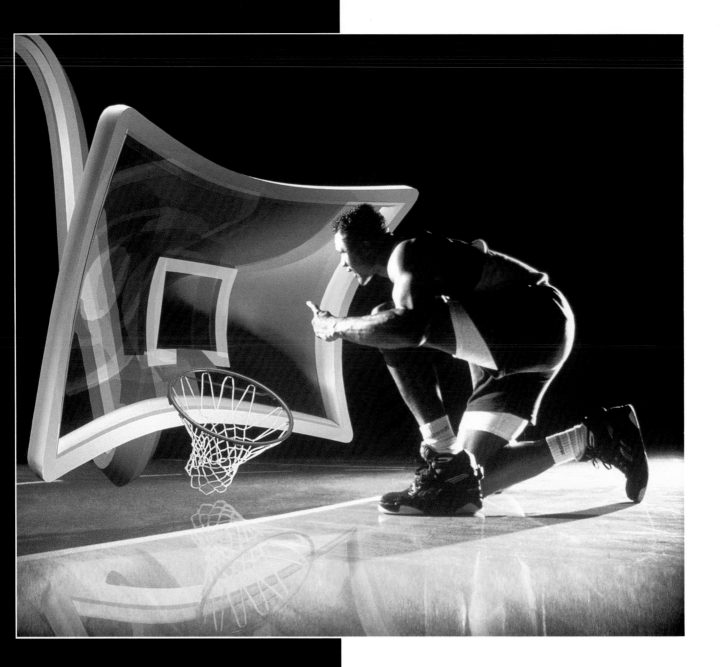

Design Firm Dewitt-Anthony, R/GA Print
Art Director Dann Dewitt
Photographer Dan Wilby
Digital Design R/GA Print
2-D, 3-D Animation R/GA Print
Hardware Macintosh, Silicon Graphics workstation
Software Adobe Photoshop, Imrender

This image was created by combining traditional photography techniques with two-dimensional compositing software.

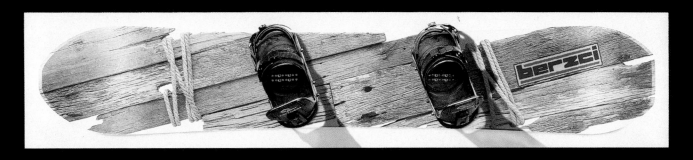

Design Firm Elton Ward Design & Photography
Designer Simon Macrae
Art Directors Simon Macrae. Steve Coleman
Photographer Andrew Kay
Hardware Macintosh
Software Adobe Photoshop. Adobe Illustrator
Client Elton Ward Design

Four photographic images were combined to create this unique snowboard. An existing snowboard was first photographed to provide a template for shape and form. Driftwood was laid within this shape, tied with rope, and then photographed. Existing shoe fittings were individually photographed. All images were combined together in Photoshop. The edges of the snowboard were further retouched to create a beveled edge, and a highlight effect was added to each end to create an upward curved impression. The logo was developed first by hand, and then rebuilt in Illustrator.

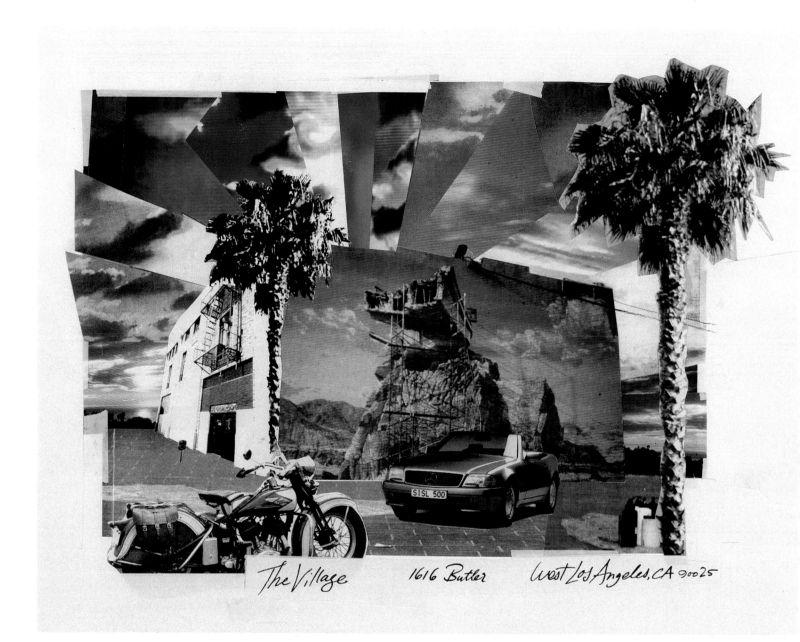

The Village 1616 Butler West Los Angeles, CA 90025

Design Firm Mike Salisbury Communications
Designer Mike Salisbury
Art Director Mike Salisbury
Illustrators Mary Evelyn McGoush. Mike Salisbury
Photographer Mike Salisbury
Hardware Macintosh
Software Adobe Photoshop
Client The Village Recorder

An older recording studio with a "fine art" reputation needed a new image for new owners—something stylish but not trendy. The computer was used to generate several layout possibilities using all of the images together.

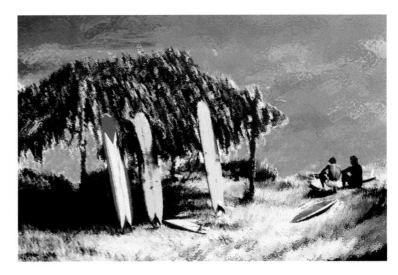

Design Firm RDDI
All Design Rick Doyle
Hardware Macintosh IIci, DayStar, Fujitsu HD
Software Adobe Photoshop, Monet

The original images were shot on 35mm film, then transferred to a Photo CD, and copied onto the hard drive. The photographs were manipulated in Photoshop and color-corrected. In the Monet program, brush strokes and textures were added, and, back in Photoshop, several images were further manipulated and combined.

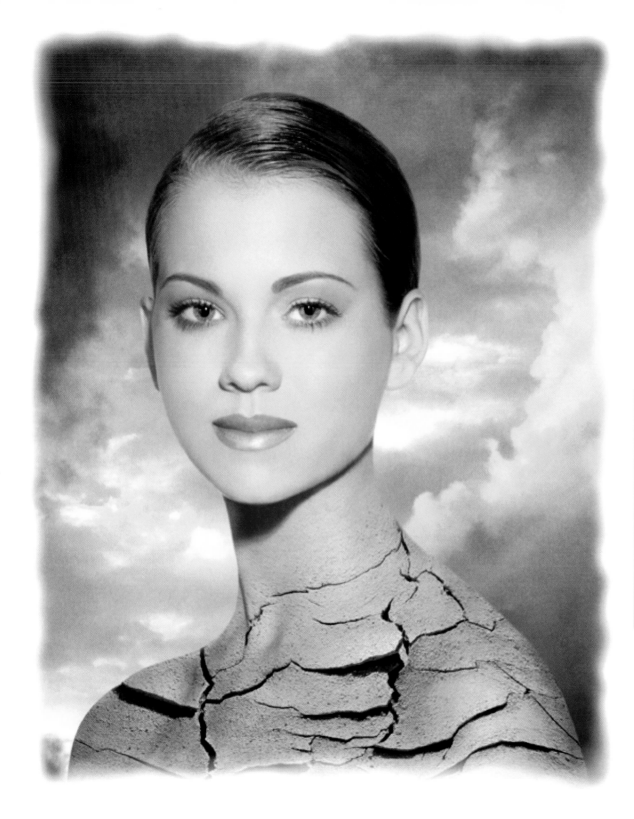

Art Director Floyd M. Dean
Illustrator Hersh Gutwillig
Photographer Floyd M. Dean
Hardware Leafscan 45,
 Macintosh and UNIX based
 work station
Client Dean Digital Imaging

For this scene, a model was photographed against a white background, and the photo was then composed onto a background image of the sky. Designers then texture-mapped an image of cracked, desert sand onto her torso.

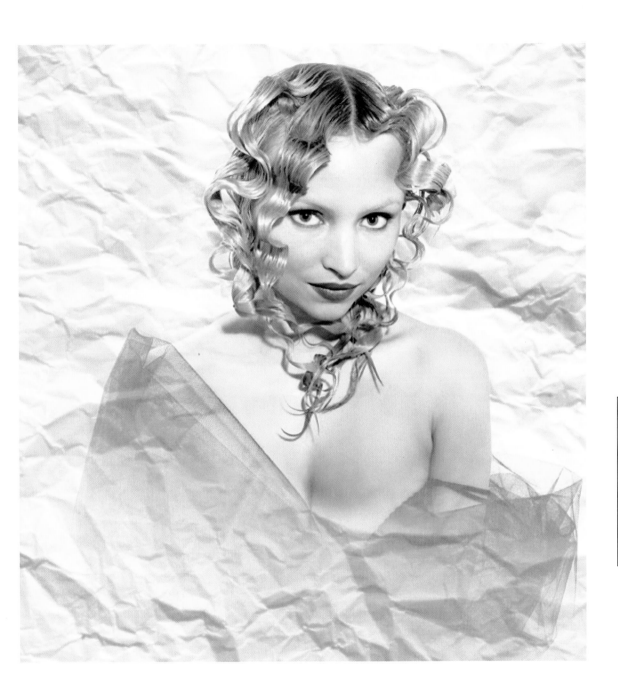

All Design Floyd M. Dean
Hardware Macintosh, Leaf Digital
 Camera Back
Client Fabrizio Salon

The wrinkled-paper background was manipulated to include a see-through portion for the model. All images were photographed for a digital quadtone image.

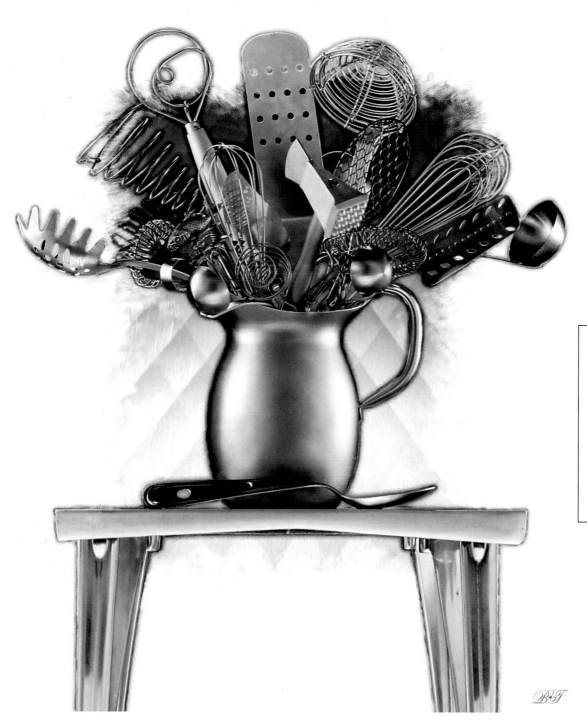

Design Firm Burke/Triolo
Designers Jeffrey Burke, Lorraine Triolo
Photographer Jeffrey Burke
Digital Manipulation Jeffrey Burke
Hardware Power Macintosh 8100/80
 170M, Wacom tablet, Scanview 5000
Software Adobe Photoshop 3.0.
 Fractal Design Painter 3.0, Color Quartet
Client Self-Promotion

The entire scene of utensils and table was shot in-studio, with a piece of catering truck metal shot separately for the background. The two images were composited in Photoshop and detailed in Painter with the large chalk brush tool.

Art Director Floyd M. Dean
Illustrator Hersh Gutwillig
Photographer Floyd M. Dean
Hardware Leafscan 45, Macintosh and UNIX based work station
Client Dean Digital Imaging

Conventional photography of 20 live snakes and a model were used in this project. Images were scanned on a Leaf scanner. The snakes were manipulated, the model photo was enhanced, and shadows were added, all on a UNIX-based system. When completed, this made over 250 snakes total on the model's head.

For this Coca-Cola advertisement, the photographer shot the original images from a moving car, using 35mm Polaroid Polapam black-and-white film to give the photographs a retro-look. These images, along with shots of a model's hand holding a bottle, were then scanned onto disks and composited in different size formats.

Design Firm Dazu, Inc.
Designer Sheri Olmon
Photographer Jeffrey Burke
Digital Manipulation Jeffrey Burke
Hardware Macintosh Quadra 950
Software Adobe Photoshop 2.5.1, Photo CD Aquire Module
Client Coca-Cola/Creative Artists Agency

Design Firm Burke/Triolo
Designer Jeffrey Burke, Lorraine Triolo
Photographer Jeffrey Burke
Hardware Macintosh II CX, 500M
 drive, 64M memory, Kurta tablet
Software Adobe Photoshop 2.0
Client Self-Promotion

Thirty-five millimeter black-and-white images of a castle kitchen interior were used for this design. Additional items were shot for the piece and inserted with a drum scanner. The designer added subtle color and distorted the castle interior shot to fit the format of the piece. He then composited the two images together and added steam to the pot for a fairy tale atmosphere.

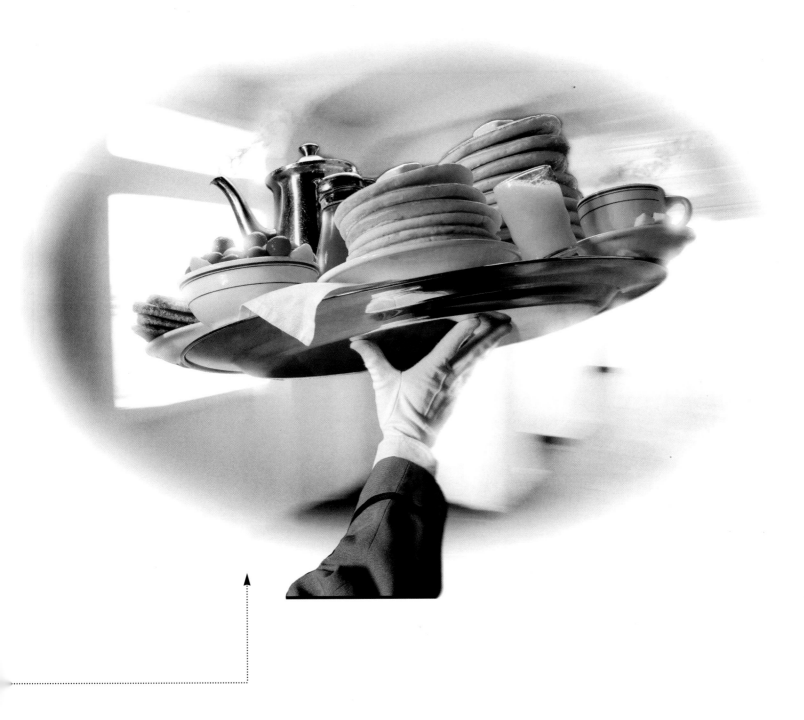

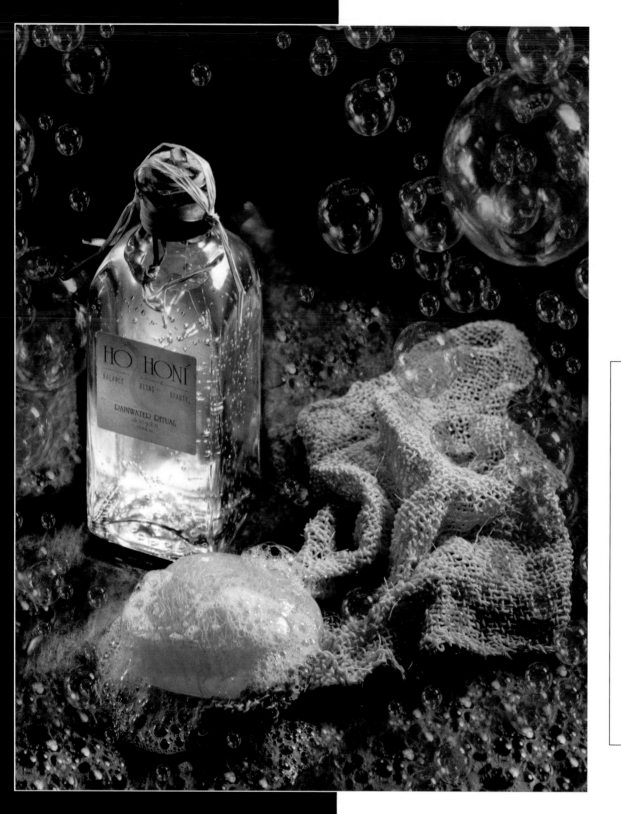

Design Firm Burke/Triolo
Designers Jeffrey Burke,
 Lorraine Triolo
Photographer Jeffrey Burke
Digital Manipulation Jeffrey Burke
Hardware Power Macintosh
 8100/80 170M, Scanview 5000,
 Wacom tablet
Software Adobe Photoshop 3.0,
 Color Quartet
Client Self-Promotion

The tray of food in this image was set up in the studio to look as though it were moving: the pancake stacks were made to lean and the orange juice glass made to appear as if it were spilling. The steam in the image was created with calcium turnings and a gentle fan. The deck of a cruise ship was photographed for the background. These images were composited together, and, using the airbrush tool, the designer enhanced the highlights around the tray to blend it into the background.

Design Firm Philip Howe Studio
All Design Philip Howe
Hardware Macintosh Quadra 950.
 Power Macintosh 200M RAM
Software Adobe Photoshop.
 Fractal Design Painter
Client Self-Promotion

This end-piece for a multi-media demo was developed from rock photographs. The three-dimensional lettering was created in Photoshop, distorted, and enhanced with blur filters. The rock image was scanned, recolored, and repainted to subtly achieve the melted edges.

Design Firm Burke/Triolo
Designers Jeffrey Burke, Lorraine Triolo
Photographer Jeffrey Burke
Digital Manipulation Jeffrey Burke
Hardware Power Macintosh 8100/80 170M.
 Scanview 5000. Wacom tablet
Software Adobe Photoshop 3.0. Color Quartet
Client Self-Promotion

Designers scanned in stock photos and manipulated the images in Photoshop. They added color, duplicated large areas of texture, took the images into Painter, and, using the "distorto brush," they distorted the edge of the plate. Additional color and texture were added with the airbrush and large chalk tools. Back in Photoshop, the center of the plate was removed and the firm's logo added.

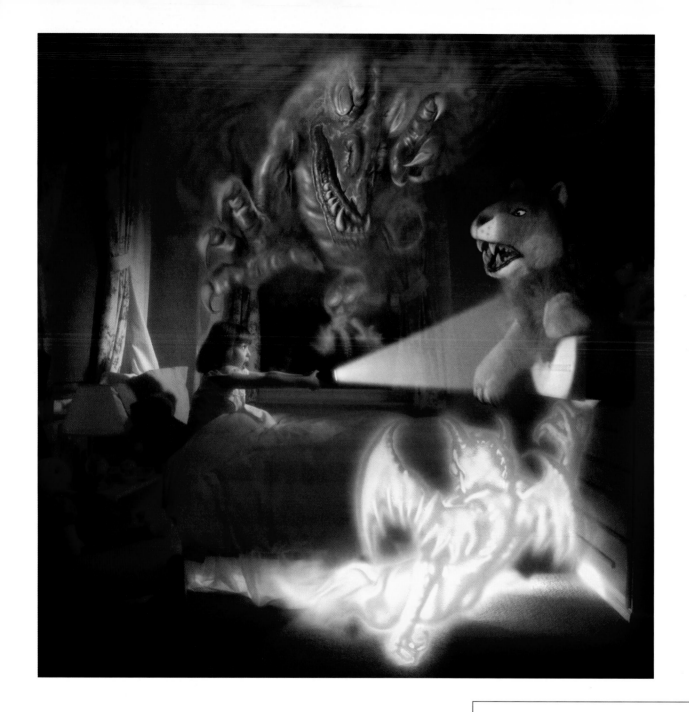

Design Firm Philip Howe Studio
Designer Philip Howe
Art Director Dianne Bartley
Photographer Ed Lowe
Hardware Macintosh Quadra 950. Power Macintosh 200M RAM
Software Adobe Photoshop. Fractal Design Painter
Client Kiwanis International

The designer scanned in the original photograph of the girl in bed. The monster and animal elements were created and painted over the photograph in Photoshop.

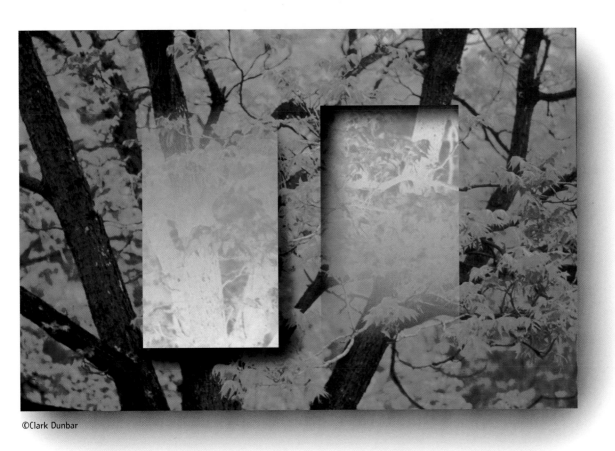

©Clark Dunbar

Photographer Clark Dunbar
Hardware Macintosh Quadra 840
Software Adobe Photoshop 3.0

Layering and shadows for this image were added in Photoshop. The interior, rectangular folds were inverted to define the layers so that the white color of these portions became black and the black became white.

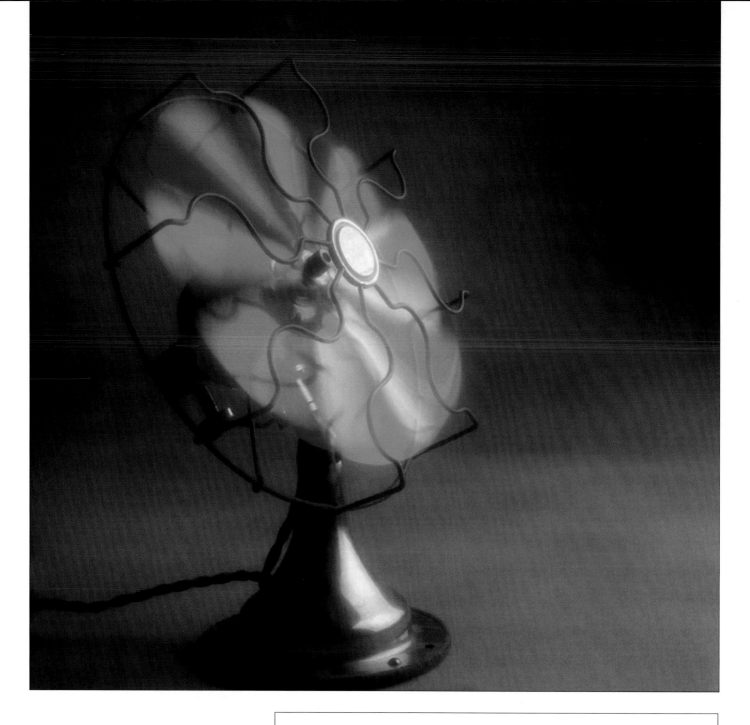

All Design Floyd M. Dean
Hardware Leafscan 45
Client Dean Digital Imaging

This image was shot digitally with a three-pass digital camera. The fan blades were moving. On each capture a filter was placed in front of the lens in which three shots were taken (red, green and blue) making a full spectrum of light. Since the fan blades were moving, the image included part of the full spectrum of color, creating a rainbow of color.

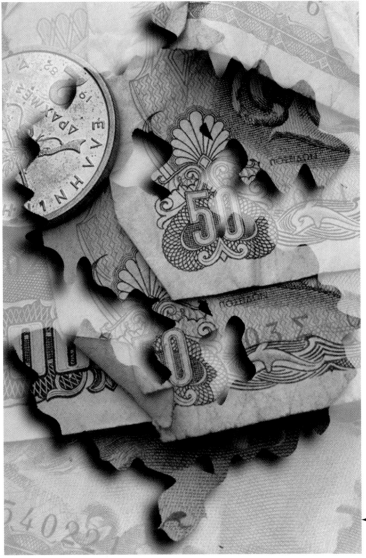

©Clark Dunbar

Photographer Clark Dunbar
Hardware Macintosh Quadra 840
Software Adobe Photoshop 3.0

This image came to life through the use of extensive layering. Standard stock photographs of money were copied and layered, with the top layer shadowed to define it from the background. The background image was altered in brightness, contrast, and saturation to further define the separate layers.

Design Firm Philip Howe Studio
All Design Philip Howe
Photographer Ed Lowe
Hardware Macintosh Quadra 950,
Power Macintosh 200M RAM
Software Adobe Photoshop,
Fractal Design Painter
Client Self-Promotion

The design goal was to create an image that appeared to be a cross between a hand drawing and a three-dimensional photo-realistic image. The designer used Painter and Photoshop to enhance the three-dimensionally embossed edges of this image, edited the color, and enhanced the photo with the "airbrush" tool.

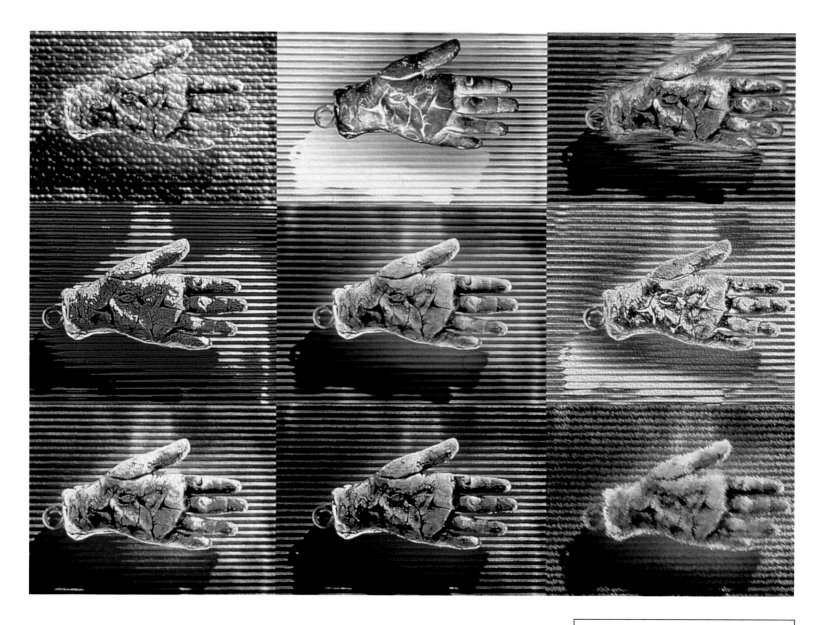

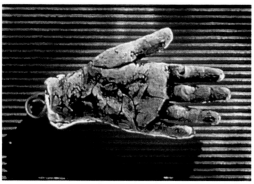

Design Firm FUSE
Designer Rich Godfrey
Art Director Rich Godfrey
Photographer Jim DiVitale
Sculptress Rosemary Mendicino
Hardware Macintosh Quadra 950,
 PC 486 DX II
Software Altsys Fontographer
Client Self-Promotion

The designer used Fontographer to create the original type placed on the hand image. The photographer experimented with different textures in various software programs, tiled images together, and output them onto color transparency film.

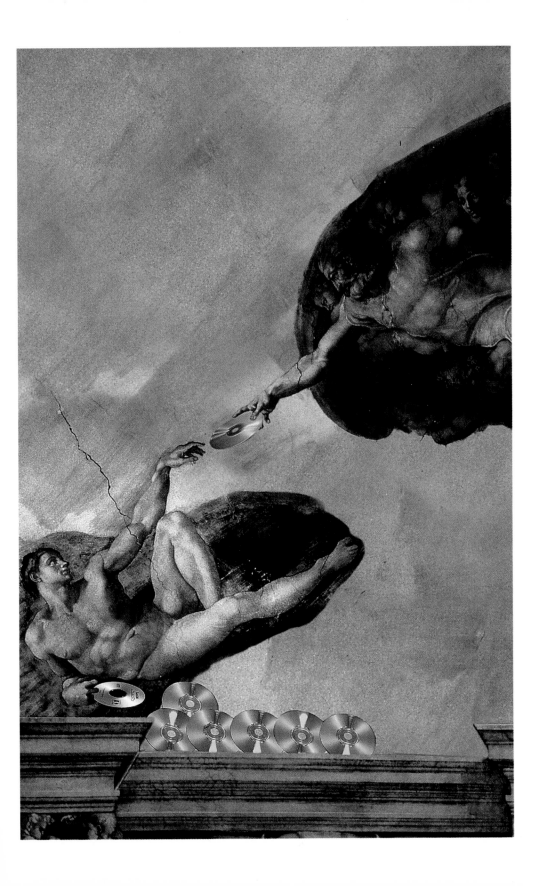

All Design Stanley Rowin
Hardware Macintosh Quadra 950
Software Adobe Photoshop
Client Boston Computer Society

This magazine cover of the compact disk issue was created with a Photo CD scan of compact disks. In Photoshop, this scan was added into the image of the Sistine Chapel. The major challenges were scanning in the images, and then making the horizontal image fit the vertical proportions of the cover.

Design Firm Multi Dimensional Images
Computer Designer Noriko Iizuka
Art Director Don Carroll, Fred J. Sklenar
Photographer Don Carroll
Hardware Macintosh Quadra 950 139M
Software Adobe Photoshop 3.0

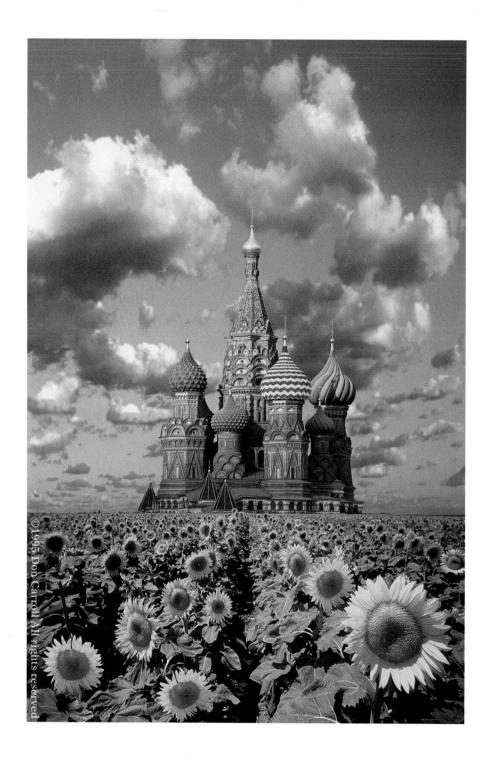

The designer took separate photographs of a sunflower field and St. Basil's church in Moscow to create this image. Both photographs were scanned, and the St. Basil's image was digitally refined on the computer by defining its color, removing the gray sky, and adding a new sky.

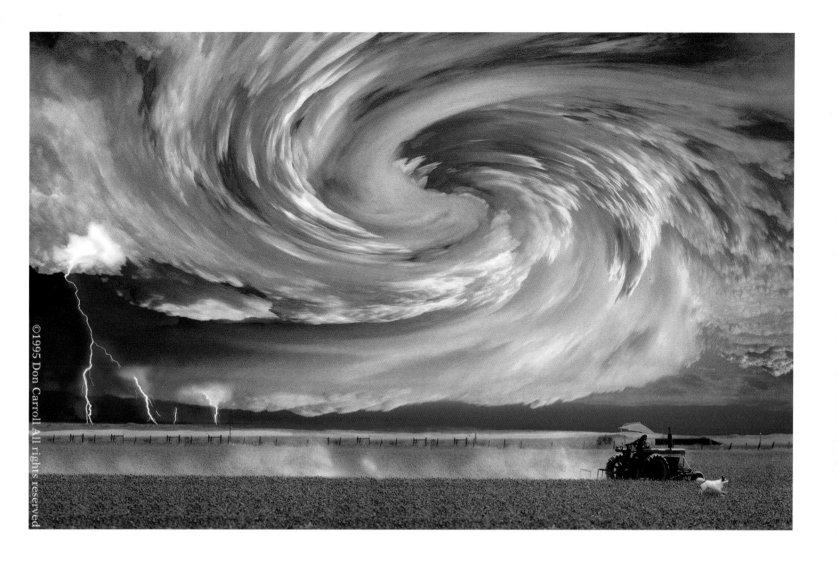

Design Firm Multi Dimensional Images
Computer Designer Noriko Iizuka
Art Director Don Carroll, Fred J. Sklenar
Photographer Don Carroll
Hardware Macintosh Quadra 950 139M
Software Adobe Photoshop 3.0

This image was created from four separate elements—the man on the tractor, the dog, clouds, and lightning. On the computer, the designer cloned the image of the field and the dust behind the tractor, and pasted it onto the original photograph, adding openness to the image. He then used the Photoshop "twirl" filter on an aerial cloud shot, and pasted the clouds into the tractor frame, smoothing out the edges. Lighting from a third image was then added, along with the manipulated photograph of the dog. Without the computer, this design would have been impossible.

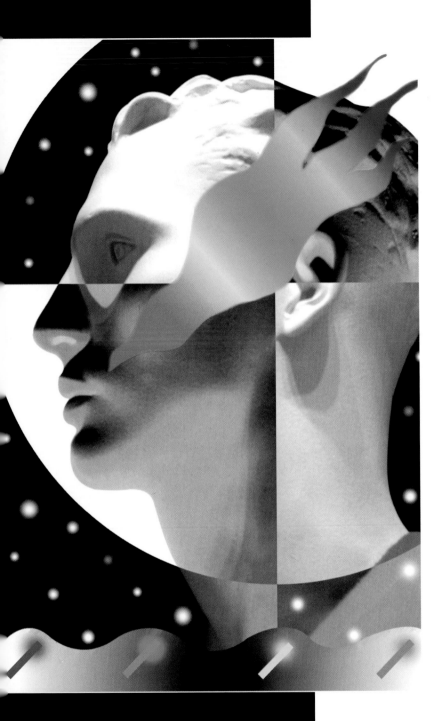

Design Firm Pat Alexander
All Design Pat Alexander
Hardware Macintosh
Software Adobe Photoshop
Client Self-Promotion

Actually a color photo, this male head looked stronger when transformed into black and white. The rainbow was added for a dash of color and contrast. After adding bits of glowing light, the designer created the bottom wavy gray blend and color diagonals to pull it all together.

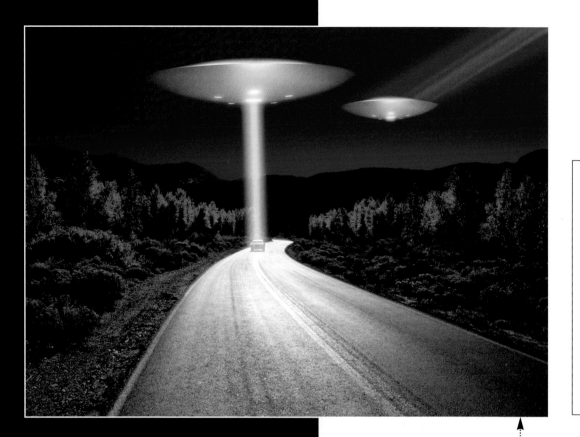

Design Firm Multi Dimensional Images
Computer Designer Noriko Iizuka
Art Director Don Carroll, Fred J. Sklenar
Photographer Don Carroll
Hardware Macintosh Quadra 950 139M
Software Adobe Photoshop 3.0

Designers built the UFO in-studio from polished, convex aluminum disks, and photographed it with a light inside of it. The background photograph of Colorado sand dunes was scanned into the computer, and the light beam was added in Photoshop. The image was feathered with more than thirty pixels and controlled with the "brightness/contrast" adjustment.

Design Firm Multi Dimensional Images
Computer Designer Noriko Iizuka
Art Director Don Carroll, Fred J. Sklenar
Photographer Don Carroll
Hardware Macintosh Quadra 950 139M
Software Adobe Photoshop 3.0

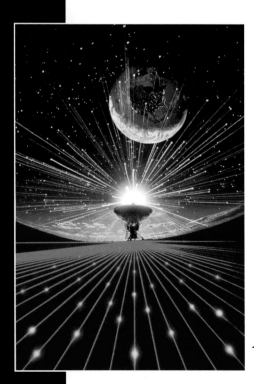

Using Photoshop, the designers combined three photographs: a radio telescope, a model of the earth with cities lit, and a glowing sun created in-studio. Red perspective lines were added on a grid to represent digital signals.

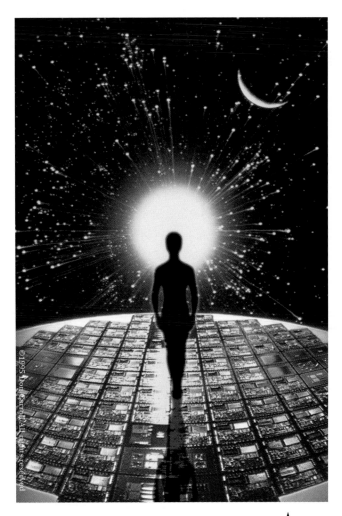

Design Firm Multi Dimensional Images
Computer Designer Noriko Iizuka
Art Director Don Carroll, Fred J. Sklenar
Photographer Don Carroll
Hardware Macintosh Quadra 950 139M
Software Adobe Photoshop 3.0

To make this image futuristic, the designers chose an outer-space image for the background. A memory computer chip was photographed and combined in Photoshop with three stock images, then the shadow of the figure was added in.

Design Firm Multi Dimensional Images
Computer Designer Noriko Iizuka
Art Director Don Carroll, Fred J. Sklenar
Photographer Don Carroll
Hardware Macintosh Quadra 950 139M
Software Adobe Photoshop 3.0

Three images, fire, the statue, and a galaxy, were scanned onto a Photo CD. In Photoshop, the statue was stripped in and placed onto the galaxy, and the fire was pasted into the torch. The fire was then retouched, distorted, and copied. An unsharp mask was finally applied to the statue to emphasize the texture.

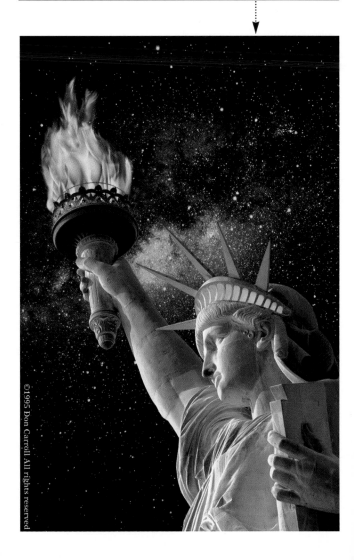

Design Firm Multi Dimensional Images
Computer Designer Noriko Iizuka
Art Director Don Carroll, Fred J. Sklenar
Photographer Don Carroll
Hardware Macintosh Quadra 950 139M
Software Adobe Photoshop 3.0, Nikon scanner

For this project, the designers used images of a window and of clouds photographed from an airplane. The earth photograph was created using a 40-inch relief model of the Earth that was built based on NASA images, and the cloud cover elements were developed from images taken from weather satellites. All of these images were scanned into the computer and assembled in Photoshop.

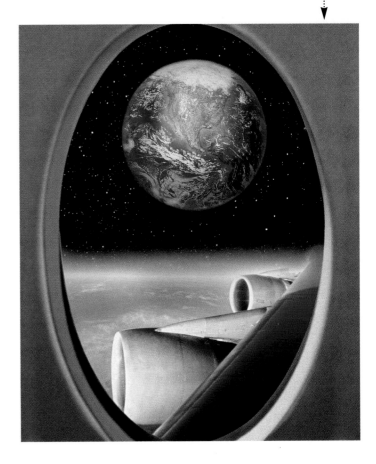

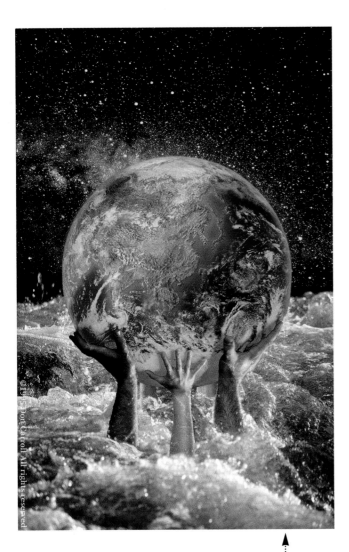

Design Firm Multi Dimensional Images
Computer Designer Noriko Iizuka
Art Director Don Carroll, Fred J. Sklenar
Photographer Don Carroll
Hardware Macintosh Quadra 950 139M
Software Adobe Photoshop 3.0

The globe in the image was placed on a hand sculpture cast in-studio, and photographed. Human hands were then photographed and placed under the globe with the use of Photoshop. This image was pasted into a photograph of rapids, and water drops were created and added in.

©J.W.Burkey

Illustrator J. W. Burkey
Hardware Macintosh II
Software Studio 8
Client Business Week

This editorial illustration of the stock exchange was created for Business Week magazine. The designer first reduced the picture to a 2-color bitmap in black and white, then colors were painted back into the image.

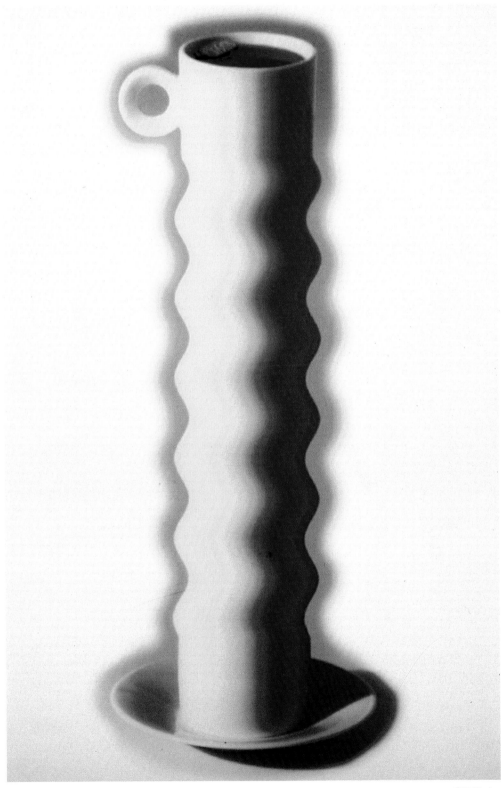

©J.W.Burkey

Design Firm D-Magazine
Designer Cynthia Eddy
Illustrator J. W. Burkey
Photographer J. W. Burkey
Hardware Macintosh II
Software Adobe Photoshop

The original photograph was shot specifically for this magazine article illustration. The image was reduced to black-and-white, the designer changed the color table, created the wavy effects with distortion filters, and stretched the image of the cup in Photoshop.

Photographer John Payne ©1995 Electric Pictures
Hardware Macintosh IIci with DayStar Turbo 040 accelerator
Software Ray Dream Designer, Adobe Photoshop,
 Adobe Illustrator, KPT Bryce
Client Self-Promotion

The company's name was being changed to Electric Pictures to reflect the increasing use of computers as well as cameras. Sections of the logo were imported from Illustrator into Ray Dream Designer where a three-dimensional image was composed, marble textures were mapped onto the various components, and the whole image was then rendered. In Photoshop, the logo was stripped into a cloudy sky image created in KPT Bryce. The type was imported from Illustrator into Photoshop.

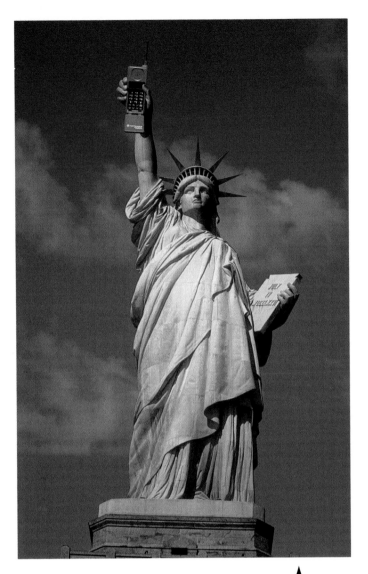

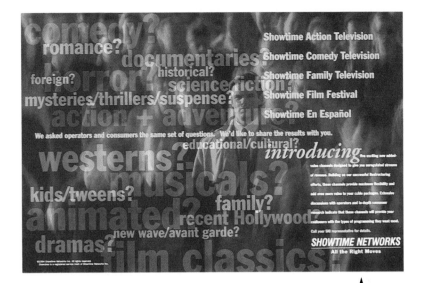

Design Firm Platinum Design. Inc.
Designer Kathleen Phelps
Art Director Kathleen Phelps
Photographer Tony Stone. Ed Pritcher
Hardware Macintosh Quadra
Software Adobe Photoshop. Adobe Illustrator. QuarkXPress
Client Showtime Networks

This advertisement launched five new channels for Showtime Networks. The imagery reflects in-depth market research used in the development of these new products. A full-color stock photo was brought into the computer as a high-resolution scan and heavily colorized in Photoshop. The background type was set in Adobe Illustrator. imported into Photoshop as three separate outlines, and saved as paths. The paths were used to select sections of the photo, which were then lightened. The entire image was saved as a TIFF and brought into QuarkXPress where the page layout was done.

All Design Stanley Rowin
Hardware Macintosh Quadra 950
Software Adobe Photoshop
Client Metro Cellular

To meet the deadline. this image was created in three days: Photographers shot the hand and phone, used stock photographs of the sky and the statue, and output to film before the deadline. Without the computer manipulation system in-house, this would not have been possible.

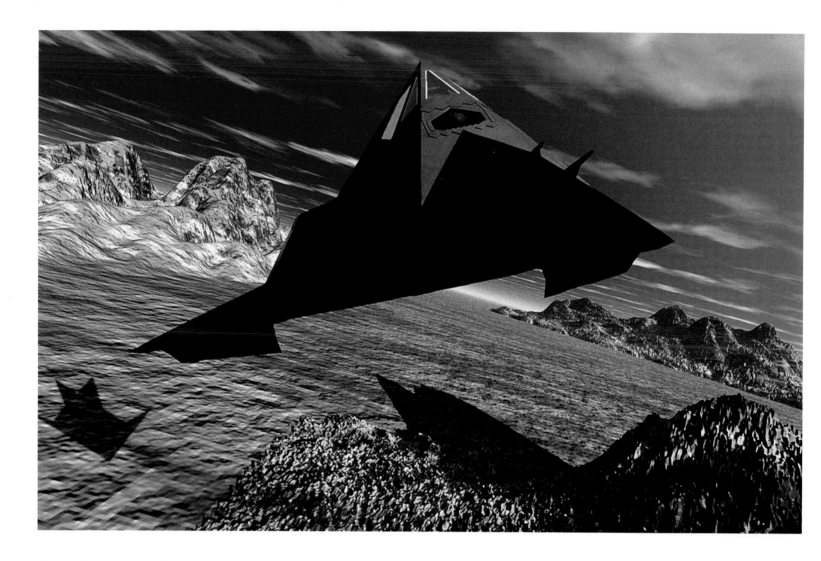

Photographer John Payne ©1995 Electric Pictures
Hardware Macintosh IIci with DayStar Turbo 040 accelerator
Software KPT Bryce. Adobe Photoshop. Adobe Illustrator
Client Self-Promotion

Photoshop was used to strip a conventional photograph of the F-117 stealth fighter (shot on the tarmac at an arch) into a desert scene rendered in KPT Bryce. The aircraft's shadow on the ground was first drawn in Illustrator, then imported into Photoshop as a channel mask.

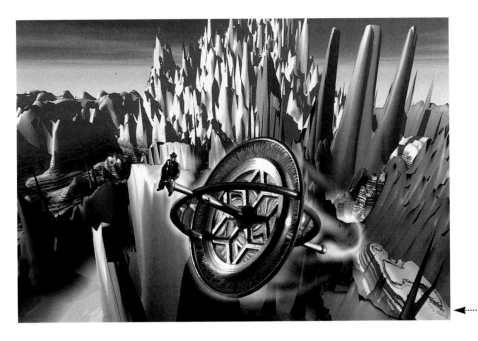

Design Firm Larry Hamill Photography
All Design Larry Hamill
Photographer Larry Hamill
Hardware Macintosh
Software Adobe Photoshop 2.5.1, KPT Bryce/KPT 2.1

A scanned photograph was used as the basis for this landscape created in KPT Bryce. Studio photos of a model and a gyroscope were pasted on the landscape, the streaks were then airbrushed with internal variations of KPT.

Design Firm Graphic Circle
Art Director Donna Mackey
Photographer John Payne
©1995 Electric Pictures
Hardware Macintosh IIci with DayStar Turbo 040 accelerator
Software Adobe Photoshop
Client Tork

The client wanted to show some rather mundane objects (photosensitive switches) in an interesting way. Since the switches are used to automatically turn on industrial lighting at sunset, the designer suggested having them appear to be floating over an urban sunset. The products were first photographed on seamless paper, scanned, stripped out, and retouched in Photoshop. Photoshop was used to combine the products with a scanned photo of the Empire State Building. A soft amber glow was added around each product.

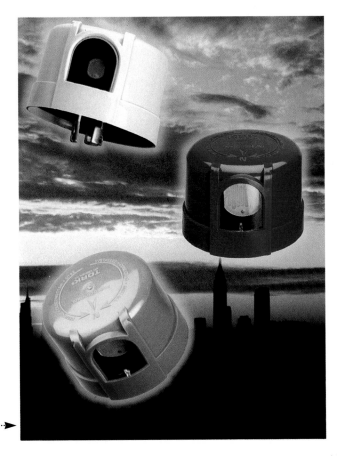

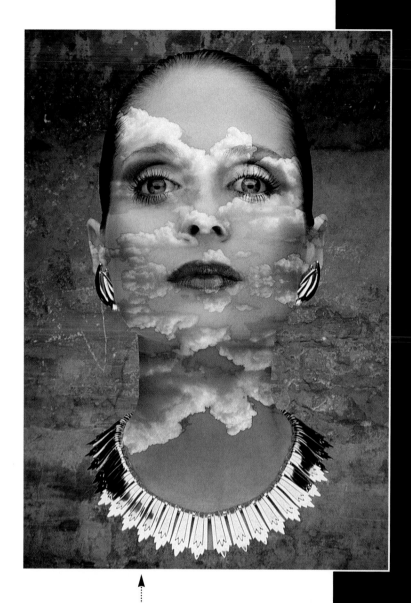

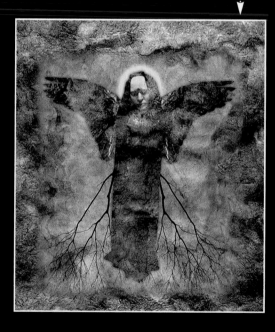

This image was created with a combination of photography and computer-generated work to look like a conventional illustration. The background was a piece of handmade paper that was scanned on a flatbed scanner. The color was then desaturated out to give the gray appearence, and the angel image was composed, flattened, and combined in Altamira Composer from four separate photographs.

Design Firm Jamie Cook, Inc.
All Design Jamie Cook
Hardware Pentium/90 256M RAM
Software Altamira Composer

This image, created as a jewelry advertisement, consists of three separate photographs—the woman, a wall, and clouds. The clouds were separated from the sky background and color-mapped onto the face of the woman.

This image was originally too muted and looked too much like an illustration. The edges of the piece were enhanced and defined with the use of sharpening filters on the computer.

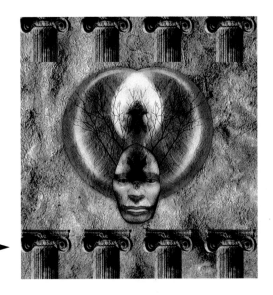

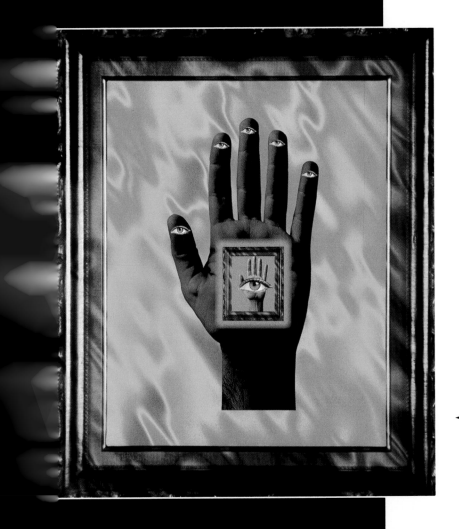

The satin background for this image and the texture of the picture frame were generated on the computer with the "textural explorer" in Kai's Power Tools. These images were then brought into Altamira Composer and assembled with scanned-in photographs of the hand and eye.

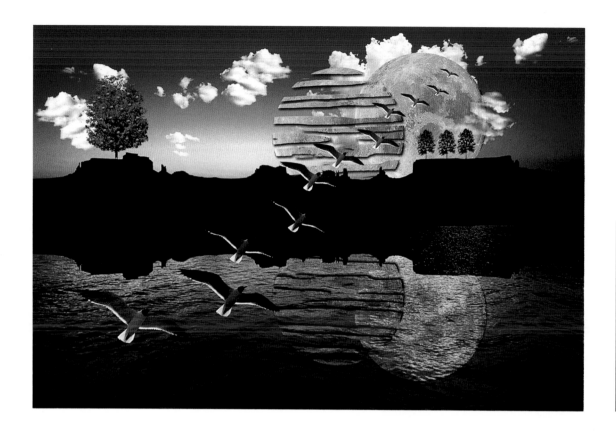

Design Firm Jamie Cook, Inc.
All Design Jamie Cook
Hardware Pentium/90 256M RAM
Software Altamira Composer

All of the images in this piece were masked using the "spline" tool in Altamira Composer, and treated as floating objects in the composition. The designer then arranged the images, repositioning as necessary.

This image combines painting and photography with an artificial sense of depth. The base image is an out-of-focus photograph of trees, and the apples were overlayed to form the illusion of depth.

122

Design Firm Jamie Cook, Inc.
All Design Jamie Cook
Hardware Pentium/90 256M RAM
Software Altamira Composer,
 Fractal Design Painter

For this project, the surface of the planets was created using Fractal Design Painter. This textured image was color-mapped to spheres that were made in Altamira Composer. All the other objects were masked using Altamira's "spline" tool, and assembled for the final image.

Design Firm Jamie Cook. Inc.
All Design Jamie Cook
Hardware Pentium/90 256M RAM
Software Altamira Composer

The design goal was to create an image from found objects—things discarded by humans and nature. All the objects were scanned directly on a flatbed scanner and arranged in Altamira Composer.

Design Firm Jamie Cook, Inc.
All Design Jamie Cook
Hardware Pentium/90 256M RAM
Software Altamira Composer,
Fractal Design Painter

This project was an exercise in textures. The textures were created in Fractal Design Painter, then imported into Altamira Composer—where they were treated as objects and arranged in the composition. The textures resemble those found in Nature: the dragonfly was intended to bridge the gap between natural textures and those generated on the computer.

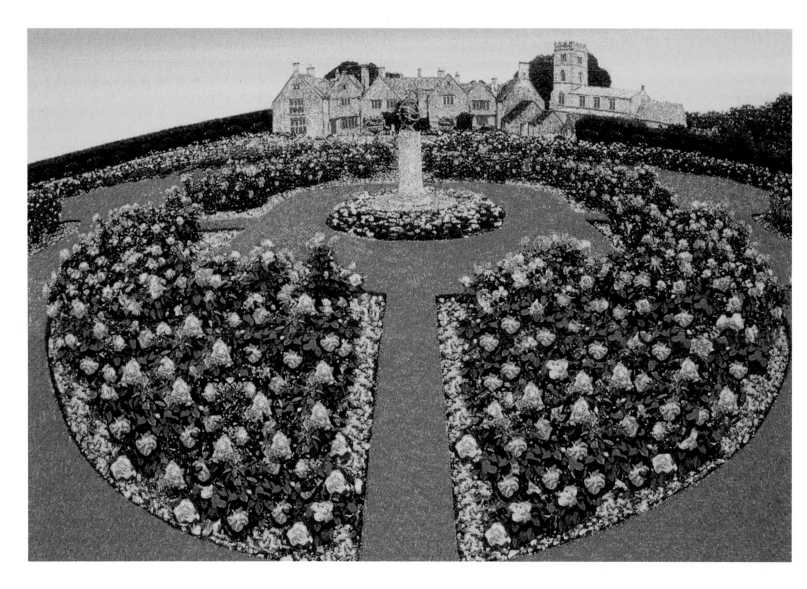

All Design Jane Gottlieb
Hardware Macintosh Quadra 950
Software Adobe Photoshop
Client Palos Verdes Art Center

This piece was created to express the designer's romantic vision of an ideal-ized world. Intensified colors were added to increase the emotional impact of the elements, while the fish-eye lens used for the original photography adds drama and worldliness to the picture. The sky and flowers were added in Photoshop, pixels were saturated with bright colors, and unwanted elements were removed from the photograph.

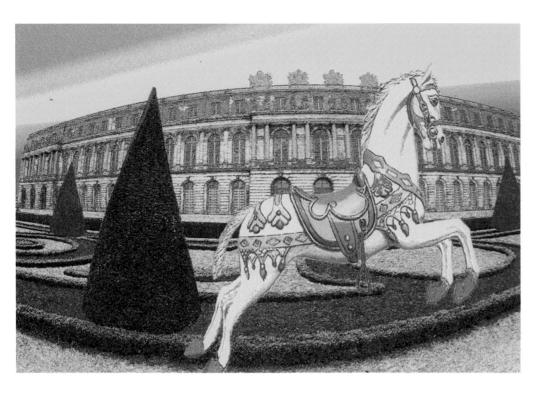

All Design Jane Gottlieb
Hardware Macintosh Quadra 950
Software Adobe Photoshop
Client Palos Verdes Art Center

The image of the carousel horse was superimposed, in Photoshop, on a photograph of the Versailles Gardens. Colors were then altered, matching the horse's color with that of the architecture, creating a dreamlike atmosphere.

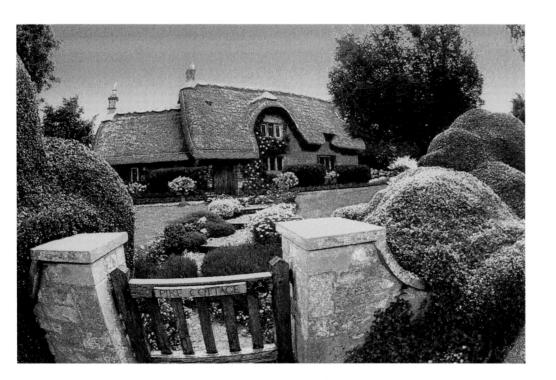

The original photograph for this project was taken with a fish-eye lens. The sky, flowers, and intense colors were all added to the scanned image on the Macintosh Quadra to produce a welcoming effect.

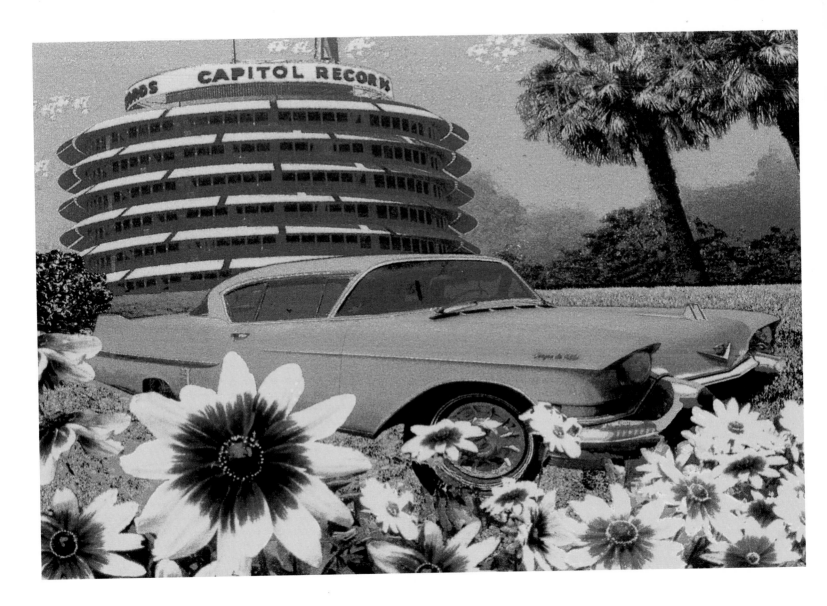

All Design Jane Gottlieb
Hardware Macintosh Quadra 950
Software Adobe Photoshop
Client LA County Petersen Auto Museum

Six separate photographs were assembled for this museum piece to portray an image of power and success. Using Adobe Photoshop, the designer scanned in and assembled the six images, and color-corrected the entire piece, creating a surreal atmosphere.

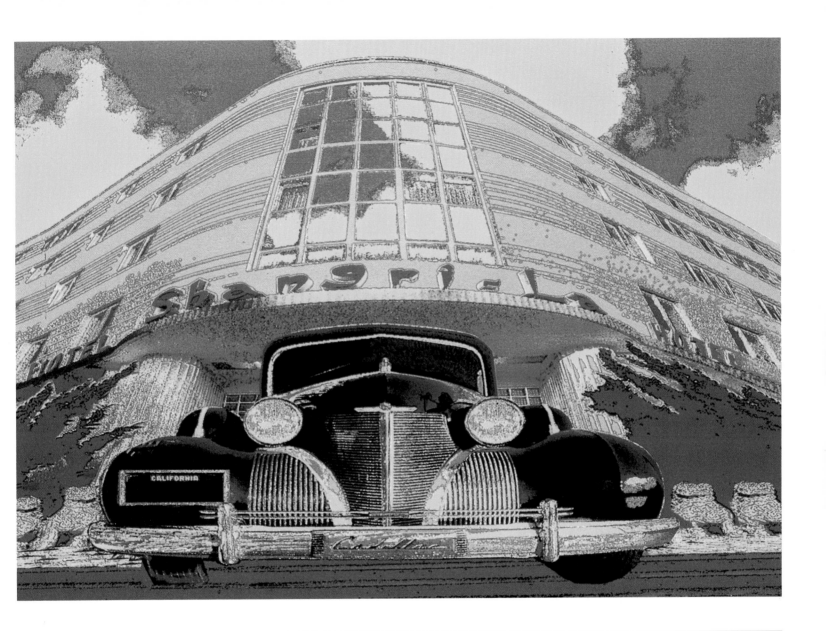

All Design Jane Gottlieb
Hardware Macintosh Quadra 950
Software Adobe Photoshop
Client LA County Petersen Auto Museum

This piece is part of a series designed for an auto museum exhibit. The designer used vintage photographs of architectural icons, classic cars, and gorgeous skies, which were then combined, painted, and enhanced in Photoshop.

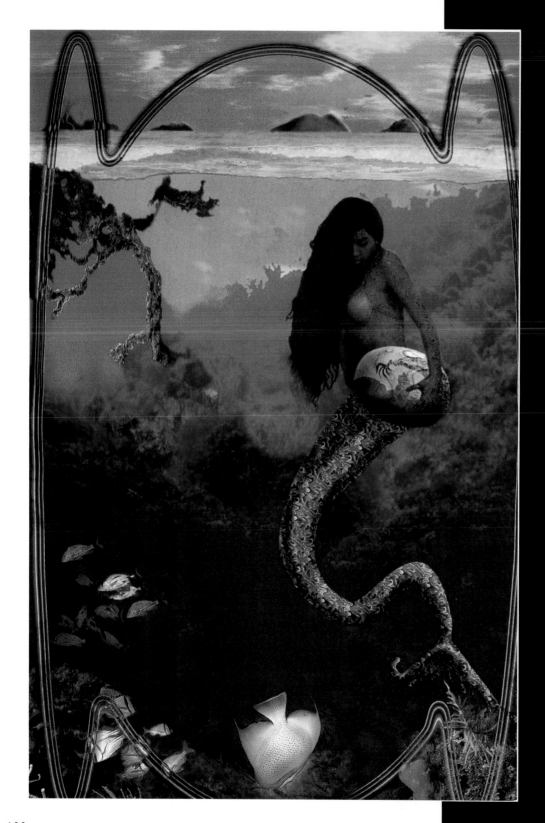

Designer Valan Evers
Photographer Valan Evers
Hardware Power Macintosh 8100,
 Syquest 88
Software Adobe Photoshop 2.5.1,
 Kai's Power Tools 2.0
Client Personal Work

The eight underwater elements, the water, sky, and clouds, are individual photographs. The model for the mermaid figure held a giant balloon to create the correct pose and shadow. The baby mermaid in the egg is composited from images of a real baby; the tail was drawn using "texture explorer" in Kai's Power Tools. Compositing the elements was relatively straightforward. The challenging aspect of this piece was integrating different water colors from many sources and adjusting them in the "hue/saturation" menu.

The background for this piece is a combination of three different shipwreck photos and scenery photographed underwater. The multiple pirates are actually manipulated versions of one person who posed "dueling" himself. Textures were developed with Kai's Power Tools. The biggest challenge was making the pirate's treasure chest, which is really a small jewelry box filled with plastic treasure—sequins, and fine gold chains—look authentic and aged.

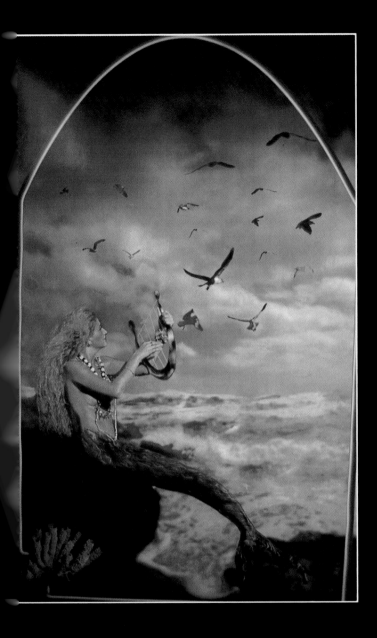

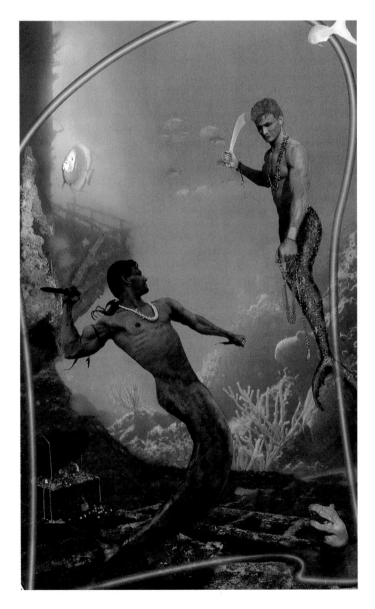

he mermaid, the rocks, the sky, the birds, the coral, and the water ere all photographed separately. The model for the mermaid held lyre made of PBC to get her hands and the shadow placed correctly. he designer of the piece then composited all of the elements together, redrawing the lyre by hand to make it look more realistic. The ermaid's tail graphics were based on a photograph of a mackerel. exture was laid over the entire image and the shadows amplified.

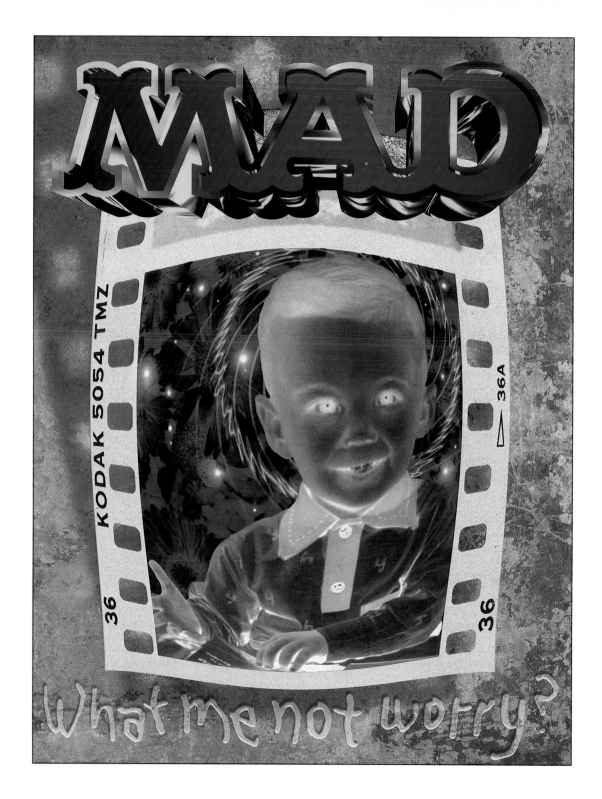

Design Firm Ferrari Color
All Design William Semo
Hardware Macintosh Quadra 950,
 Somet 455, LVT Saturn 1010
Software Adobe Photoshop,
 Adobe Illustrator
Client Self-Promotion

This self-promotion piece demonstrates the lighter side of digital design and photography. The reference to "what me not worry" is indicative of the care and effort that goes into all of this firm's work.

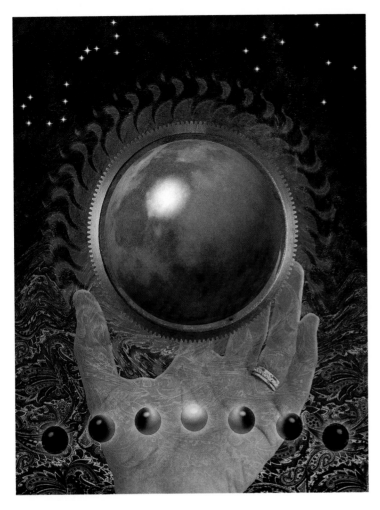

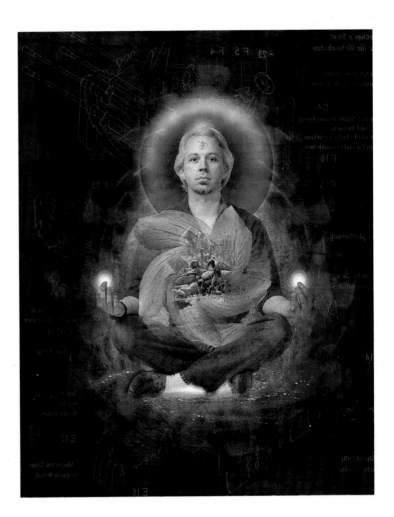

Design Firm Ferrari Color
All Design William Semo
Photographer Shauna Law, house stock photography
Hardware Macintosh Quadra 950, Somet 455, LVT Saturn 1010
Software Adobe Photoshop, Adobe Illustrator, Kai's Power Tools
Client California Computer News

Design Firm Ferrari Color
Designer William Semo
Art Director William Semo
Illustrators William and Susan Semo
Photographer Ronnie Johnson
Hardware Macintosh Quadra 950, Somet 455, LVT Saturn 1010
Software Adobe Photoshop, Adobe Illustrator
Client Self-Promotion

For this project, designers wanted to show ancient alchemy in an updated way. Old images were combined digitally to demonstrate "modern magic," and all the work was done through channel manipulations and digital illustration. Without the computer, the handwork required to create the same image would have been extremely cumbersome.

This design was part of a campaign of self-promotion to show the firm's evolution into computer design and imaging from traditional photographic processes. The design team used heavily altered multi-media (painting, illustration, photography) along with various Photoshop channels.

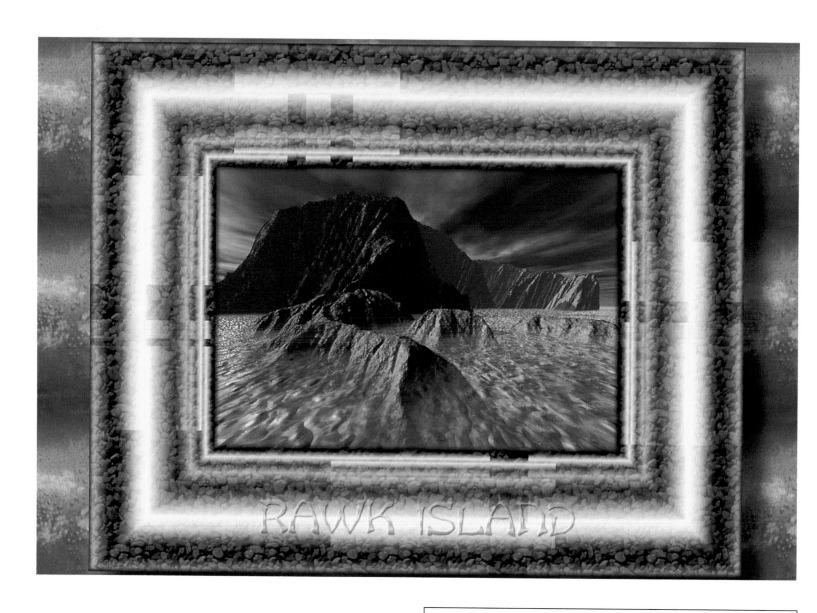

Design Firm Ferrari Color
Designer Mitchell Dullanty
Photographer Mitchell Dullanty
Hardware PC 485 DXZ, Macintosh Quadra 950
Software Adobe Photoshop, Pixar 128, KPT Bryce
Client Personal Project

A watermelon was photographed and manipulated to create a unique background for this simulated painting. The photo of rock texture was taken from a Pixar 128 CD, and the center landscape was created in KPT Bryce, a three-dimensional rendering program, and composited in Photoshop.

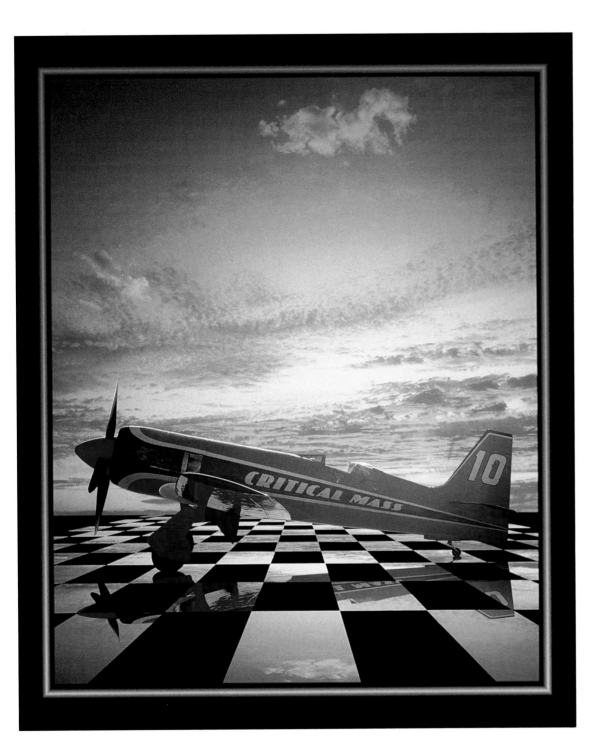

Design Firm Ferrari Color
Designer Mitchell Dullanty
Photographer Mitchell Dullanty
Hardware PC 486 DXZ
Software Adobe Photoshop.
 CorelDraw
Client Personal Project

For this photograph. the background and foreground and surrounding equipment were all removed. The photograph of the sky was taken independently. CorelDraw was used to create an EPS file of perspective tiles; compositing color enhancement and producing the border reflection were completed in Photoshop.

©J.W.Burkey

Photographer J. W. Burkey
Hardware Dicomed
Software Dicomed
Client Burkey Studios

The designer scanned the original image twice, once about fifteen percent larger than other, and then pasted the large mouth onto the regular-sized face.

Photographer J. W. Burkey
Hardware SUPERSET
Software SUPERSET

Created for an exhibition, this image was made from the two studio photographs of the same man which were then combined by a lab.

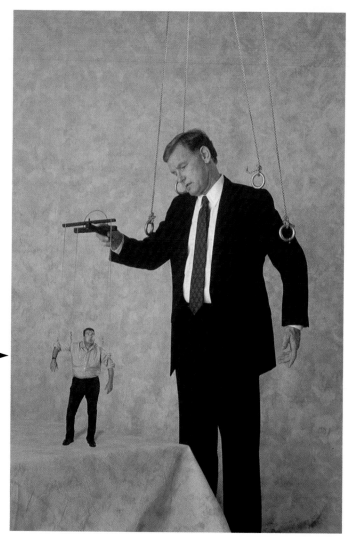

©J.W.Burkey

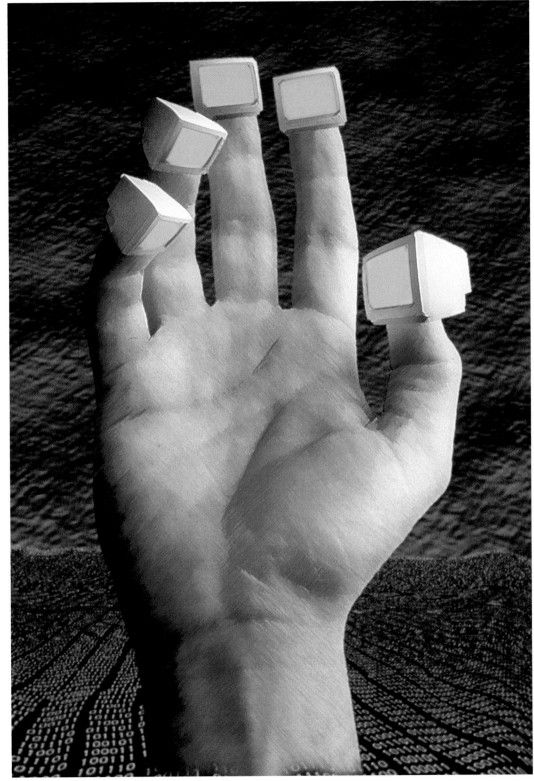

Design Firm DDB Needham/Chicago
Art Director Byron Reaves
Illustrator J. W. Burkey
Photographer J. W. Burkey
Hardware Quadra 950
Software Fractal Design Painter.
 Specular Collage. Adobe Photoshop
Client Software Spectrum

The assignment was to illustrate office networking software. Designers first photographed the hand. and then shot five monitors to match the angle of the fingers on the desired frame.

Design Firm Chromatics Photo Imaging
Designer E. Q. Vance
Computer Illustrator Ron Hill
Photographer Bob Schatz
Hardware Quadra 950
Software Adobe Photoshop
Client WSMU Television

This image was used as a 4- by 26-foot backlit film for a television news set. The designers' low resolution layout was reproduced in ultra-high resolution, and 11 images were combined to create the final montage.

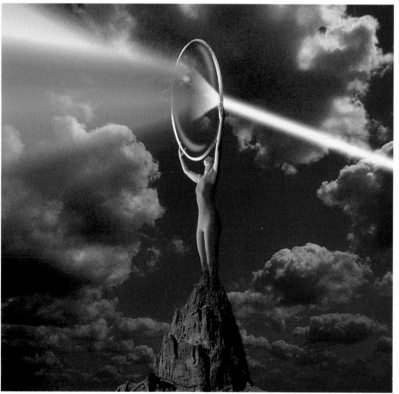

©J.W. Burkey

Art Director Kim Morneau
Illustrator J. W. Burkey
Photographer J. W. Burkey
Hardware Quadra 950
Software Fractal Design Painter,
 Specular Collage, Adobe Photoshop
Client CIO Magazine

To illustrate the idea of converging technology, the designers combined stock images of the mountain and the sky, photographed the person and the lens in-studio, and developed the rainbow with KPT.

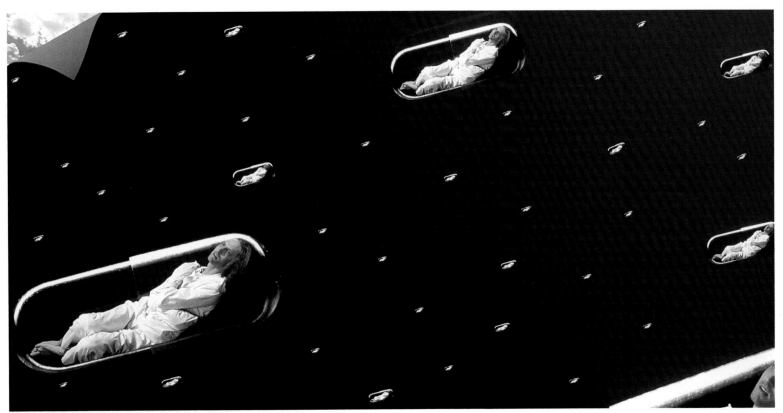

©J.W. Burkey

Photographer J. W. Burkey
Hardware SUPERSET
Software SUPERSET

Designed for display in a gallery show, this piece combines studio photographs of the man and the pill. A stylist created the straight jacket, and a photo-technician placed the man in the capsule and repeated the image.

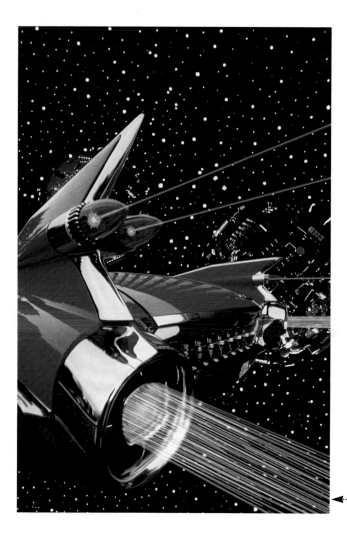

Design Firm Larry Hamill Photography
All Design Larry Hamill
Hardware Macintosh
Software Adobe Photoshop 2.5

This startling image began with a Cadillac photo that was taken outside, a wide-angle 14 mm lens was used to distort the wings of the car. The designer then took studio photos of micro-chips placed on painted Styrofoam spheres. The stars were created in Photoshop, along with the laser-trails, which were developed with the "airbrush" tool.

Design Firm Larry Hamill Photography
All Design Larry Hamill
Hardware Macintosh
Software Adobe Photoshop 2.5.1. Fractal Design Painter

This photograph of a window in France was pasted onto a triple exposure of a venetian blind; the designer then pasted in a photograph of a man holding an object. The object was deleted in Photoshop using a "cloning" tool, and Fractal Design Painter was used to created the stream of energy that the man appears to be holding.

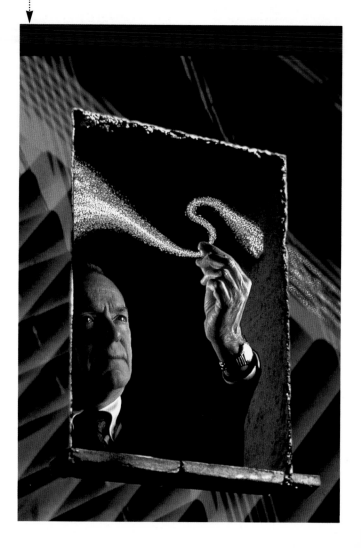

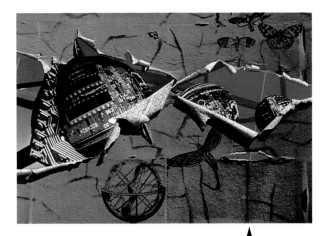

Design Firm Larry Hamill Photography
All Design Larry Hamill
Hardware Macintosh
Software Adobe Photoshop 2.5

This image was created in Photoshop with the use of a triple exposure of architecture, macro-photos of circuit boards and spheres (created with Kai's Power Tools) pasted onto the architecture. Old engravings were scanned into the computer, copied, and pasted onto the photograph of the wall with the use of the "darken" tool that allows only the dark portions to be copied.

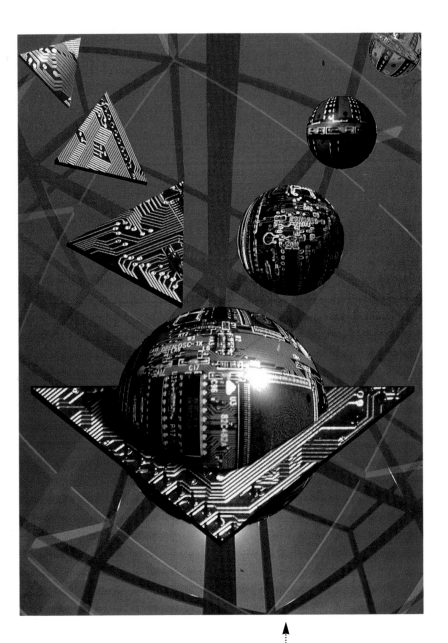

Design Firm Larry Hamill Photography
All Design Larry Hamill
Hardware Macintosh
Software Adobe Photoshop 2.5, KPT Bryce

The designer began this project with a multiple exposure of the architecture. The merging spheres were created by distorting macro-photos of circuit boards by spherizing and sharpening the images in KPT Bryce.

141

D i r e c t o r y

Pat Alexander
19 E. 83rd Street
New York, NY 10028

Animus Comunicaçáo
Ladeira Do Ascurra 115-A
22241-320 Rio de Janeiro
Brazil

David Blattel Studios
8659 Hamden Place
Culver City, CA 90290

Burke/Triolo
8755 Washington Boulevard
Culver City, CA 90232

J.W. Burkey
1526 Edison Street
Dallas, TX 75207

Jamie Cook, Inc
1740 Defoon Place
Atlanta, GA 30318

COY, Los Angeles
9520 Jefferson Boulevard
Culver City, CA 90232

Michael Davighi Associates Limited
Elton House
Powell Street
Hockley Birmingham B13DH
England

Jamie Davison Design, Inc.
444 De Haro Street, Suite 212
San Francisco, CA 94107

Floyd M. Dean
2-b S. Poplar Street
Wilmington, DE 19801

Clark Dunbar
1235 Pear Avenue #100
Mountain View, CA 94043

EB Graphics
P.O. Box 1418
Cupertino, CA 95015-1418

Valan Evers
140 N.E. 22nd Street
Wilton Manors
Ft. Lauderdale, FL 33305-1014

Ferrari Color
2574 21st Street
Sacramento, CA 95818

Jane Gottlieb
544 Dryad Road
Santa Monica, CA 90402

Larry Hamill Photography
77 E. Deshler
Columbus, OH 43206

Hornall Anderson Design Works
1000 Western Avenue #600
Seattle, WA 98104

Philip Howe Studio
540 1st Avenue S.
Seattle, WA 98104

Imaginings Computer Graphics
245 S. Serrano Avenue, Suite 318
Los Angeles, CA 90004

Lightstream
9 May Street
Beverly, MA 01915

Robin Lipner Digital
220 W. 21st Street, 2E
New York, NY 10011

Melkus Photography
679 E. Mandoline
Madison Heights, MI 48071

Millennium Studios
224 N. Madison Street
Stoughton, WI 53589

Muller + Company
4739 Belleview
Kansas City, MO 64112

Multi Dimensional Images
188 Grand Street
New York, NY 10013

O & J Design, Inc.
9 West 29th Street
New York, NY 10001

Kiku Obata & Company
5585 Pershing Avenue #240
St. Louis, MO 63112

Mervil Paylor Design
1917 Lennox Avenue
Charlotte, NC 28203

John Payne ©1995 Electric Pictures
43 Brookfield Place
Pleasantville, NY 10570

Platinum Design
14 W. 23rd Street
New York, NY 10010

Mike Quon Design Office
568 Broadway
New York, NY 10012

Raging Pixels/Routch Design
1000 Conestoga Road, Suite C266
Rosemont, PA 19010

RDDI
232 N. Sierra Avenue
Solma Beach, CA 92075

Research Communicatiions Center
University of Dayton Research Institute
Building 562, Williams Gateway Airport
6001 S. Power Road
Mesa, AZ 85206

Stanley Rowin
791 Tremont Street W515
Boston, MA 02118

R/GA Digital Studios
350 W 39th Street
New York, NY 10018

Mike Salisbury Communications
2200 Amapola Court, #202
Torrance, CA 90501

Beth Santos Design
2 Village Hill Lane
Natick, MA 01760

Satterwhite Productions, Inc.
P.O. Box 398
Concord, VA 24538

Studio 212°
2400 McKinney Avenue
Dallas, TX 75201

Vaughn Wedeen Creative
407 Rio Grande N.W.
Albuquerque, NM 87104

The Vision Factory
205-28 Brian Crescent
Bayside, NY 11360

Elton Ward Design
4 Grand Avenue
P.O. Box 802
Parramatta
NSW 2150
Australia